C000070830

THE SPACES BETWEEN BUILDINGS

CENTER BOOKS ON SPACE, PLACE, AND TIME

George F. Thompson, Series Founder and Director

Published in cooperation with the Center for American Places
SANTA FE, NEW MEXICO, AND HARRISONBURG, VIRGINIA

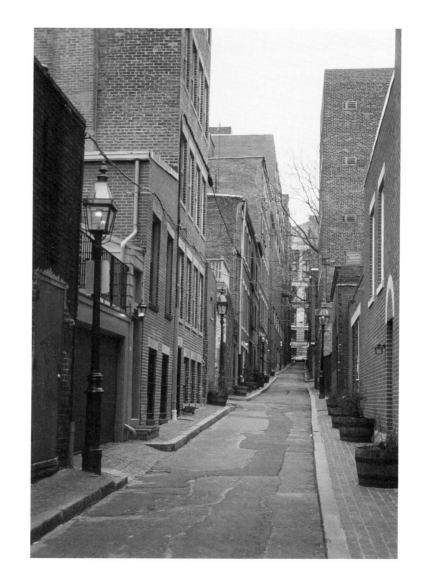

The Spaces between Buildings

LARRY R. FORD

THE JOHNS HOPKINS UNIVERSITY PRESS || BALTIMORE AND LONDON

© 2000 The Johns Hopkins University Press
All rights reserved. Published 2000
Printed in the United States of America on acid-free paper
9 8 7 6 5 4 3 2 1

The Johns Hopkins University Press
2715 North Charles Street
Baltimore, Maryland 21218-4363
www.press.jhu.edu

All photographs are by the author, 1972–98.

Library of Congress Cataloging-in-Publication data
will be found at the end of this book.

A catalog record for this book is available from the British Library.

ISBN 0-8018-6330-9 ISBN 0-8018-6331-7 (pbk.)

FRONTISPIECE: A well-kept alley in central Boston

The time may soon come when planners, designers, developers, and others will recognize and act on the simple notion that the spaces between buildings are as important to the life of urban man as the buildings themselves.

SERGE CHERMAYEFF AND CHRISTOPHER ALEXANDER,
Community and Privacy

Contents

ACKNOWLEDGMENTS

For as long as I can remember, I have been an avid ogler of the urban scene. Even as a tyke, when traveling across the country, I tried to keep track of which cities had the tallest buildings and what towns had the most interesting houses. Imagine my delight when I discovered, in the geography graduate program at the University of Oregon, that it was possible to make a career of looking at the landscape. All of the faculty, but especially Everett Smith and Ed Price, encouraged me to develop ideas based on the reading and mapping of ordinary landscapes. Over the ensuing years, editors such as Douglas McManis and Paul Starrs at the *Geographical Review* and George F. Thompson at the Center for American Places have seen fit to publish many of my observations and interpretations.

For several decades now, my wife, Jan, along with a wide variety of friends, colleagues, and students, have put up with my stopping to perceive and ponder the "nooks and crannies" of city neighborhoods. Although my main interest has always been buildings, in recent years I have found myself spending

more time looking at the intervening spaces between them—
the spaces that surround, enclose, and channel our activities.
On long strolls through urban neighborhoods—Jan calls them
forced marches—I can't help but notice such minutiae as the
size and shapes of alleys and patios and fire escapes that hang
precariously over dumpsters. These are often remarkably inter-
esting things, but they are seldom given much attention in stan-
dard books on arhitecture and places. This book is an attempt
to provide an answer to the question I am most often asked on
city walks: "What the heck are you staring at now?"

ACKNOWLEDGMENTS

THE SPACES BETWEEN BUILDINGS

INTRODUCTION || The Nooks and Crannies of Everyday Life

THE SPACES SURROUNDING BUILDINGS LOOM LARGE IN MY memories of growing up in the city. Long before I had any idea about various architectural styles or even the relative size and cost of houses, I knew something about the spaces adjacent to, beside, behind, in front of, and even on top of many of the buildings in my neighborhood—in short, the spaces *between* buildings. I knew who had the best front porch for whiling away the hours with comic books, where the best front steps were for schmoozing with neighbors, where the most interesting loading docks were in the alleys behind stores, which trees to climb for water-balloon wars, and where to find basketball hoops hung on the alley sides of prefab garages from Sears.

The nearby commercial streets had rooftops and fire escapes ideally suited for watching parades and storefronts with indented entryways and display windows, perfect places for chatting or waiting for a bus. There were also cellar doors and coal chutes to play in and grape arbors to scale. There were lots of places to hang out, and, at least in my memory, they all seemed to be wonderfully integrated and connected. Because of my lifelong interest in these ordinary spaces, I often wonder what

it is like to grow up in homogeneous settings like the storeless, alleyless housing tracts where things are arranged differently, without all those interesting spaces and places. After decades of taking photographs and analyzing the styles and functions of buildings, I now find myself preoccupied with back doors, alleys, sidewalks, and fire escapes. I find these scenes fascinating and I hope that you will, too.

Scholars generally pay little attention to the ordinary, everyday spaces between buildings. Architectural histories and guidebooks tell us surprisingly little about the character of American cities, precisely because they concentrate on buildings; that is, buildings divorced from space. Photographs depicting houses, office buildings, and hotels, when taken out of context, fail to tell the whole story. This is especially true in the loose urban fabric of the modern North American city, where there is rarely the kind of enclosing built environment that we associate with more traditional European cities. Rather, buildings of all kinds, from houses and apartments to office buildings and shopping centers, stand alone as separate structures, each relating (or not relating) as best it can to the surrounding spaces.

This book is about the ordinary spaces between buildings, including those architectural features like window types and door placements, which influence how a building relates to the spaces around it. Thus I talk about such things as porches, steps, walkways, gates, gardens, driveways, sidewalks, lawns, street trees, alleys, patios, decks, cellar doors, fences, courtyards, parking lots, loading docks, sidewalk cafes, and storage areas. I introduce several larger urban design concerns along the way, such as the economic and social impact of the increasing dominance of space over buildings in the modern American city, but the book is not primarily about such big issues.

Rather, it is about details. Each of the three sections that follows includes observations of different types of ordinary spaces, speculations on how and why they evolved, what they mean in our everyday lives, and what trends exist that might change things in the future. Each section is followed by a photo essay that helps bring more insight into the importance of these spaces.

It is difficult to come up with an appropriate classification scheme for the three sections of the book, since the spaces between buildings are often multipurpose and have different meanings for different people at different times. There is the danger that giving a name to a type of space might overly define it. I also want to clarify just how I am using the word *between*. In this book, I include in the definition of spaces between buildings both the semiprivate areas that surround and even cloak buildings, such as doorways, stairways, and porches, and the spaces that are more literally between buildings, such as sidewalks and parking lots. With this in mind, the three parts of the book are organized as follows: (1) architectural forms, facades, and embellishments (enclosers of space), (2) lawns, gardens, and other vegetation (shapers of space), and (3) streets, alleys, and parking areas (shapers of access). Despite some exceptions to the suggested organizational framework, the intent is to start at the skin of buildings (doors, windows, texture) and to work outward, through front steps, lawns, and gardens, to the sidewalk and the street.

The first essay deals with the evolution of the free-standing structure as a basic urban building type and with the problems encountered in "decorating" not only the traditional facade fronting a street or square but also the increasingly visible sides and backs of structures. How has the visibility of workaday back- and sideyards helped to create the image of an untidy and

sometimes ugly American city? This essay also focuses on the ways in which the ever-increasing numbers of spaces around and adjacent to buildings, especially in the North American city, have been designed, filled, and embellished. I examine the role of stoops, porches, stairs, gates, patios, and decks as items occupying the zone of public-private interaction between individual buildings and the public spaces beyond.

The second essay deals with the ways that North American city dwellers have used grass lawns, gardens, hedges, trees, and other forms of vegetation to separate and beautify the spaces between buildings. Here I examine the trend toward viewing such vegetation as an essential adjunct to architecture. The house without a front lawn, for example, is usually viewed negatively and simply not allowed in many communities. Anglo-American style gardens, trees, and ivy-covered walls have become an inseparable part of many urban and suburban scenes. Green spaces have become as American as apple pie, but planners and residents now disagree on just how much space should be given over to aesthetically pleasing but often underutilized and water-intensive lawns. While vegetation is used as a buffer between buildings, defining and softening many of our urban spaces, it also is used to create massive, prickly "hedge-walls," which make buildings less approachable. Both softening and fortifying vegetation can hide and otherwise diminish the impact of mediocre or incompatible architecture.

Finally, I examine the traditionally public pedestrian and vehicular spaces that give access to buildings and define their location. Here I include the landscape of the garage, sidewalk, and street. In most traditional cities, before the common use of vehicles, the street was an extension of the buildings that faced it. People sat in chairs in front of their homes, and businesses displayed goods on rugs and tables in the street. With the rise

of horse-drawn and then motorized vehicles, the street became less a part of the community and more of a place for transient strangers, people passing through. The invention and gradual proliferation of sidewalks, kiosks, sidewalk cafes, and streetside trees have helped to soften the interface between buildings and the street, but controversies continue. To what degree should businesses and residences be allowed to expand into and personalize the public domain? Should the street be part of the store?

Streets are places not only for movement but also for parking. As street parking becomes more and more inadequate, parking lots have invaded many of the spaces around, behind, in front of, and under buildings. The design of parking lots, driveways, domestic and commercial garages, and other dimensions of the building-vehicle interface is now one of the major challenges to the planners and builders of the contemporary North American city.

The Importance of Ordinary Spaces

My concern in each of the three essays is much more with ordinary, vernacular spaces than with monumental and symbolic ones (although the design of the latter often influences the design of the former). Grand spaces—Place des Vosges in Paris, Grosvenor Square in London, or Rockefeller Center in New York City—are carefully contrived architectural statements in themselves. They are hardly ordinary. A vast literature already exists on the design of city squares, courthouse squares, and grand promenades. I am after the ordinary. I also avoid, except for comparison to make a point, the topic of large public parks and other planned open spaces. Parks, except perhaps for the small, vest-pocket variety, are designed to be places in their own right, not spaces between buildings. Of course, the bound-

ary between monumental or large-scale spatial arrangements and small or ordinary ones is sometimes a bit fuzzy. To a small child, a tiny garden can be a monumental space.

An important question thereby arises: When does "space between buildings" become "open space containing buildings?" When does the defined, enclosed, relational space between buildings become the open, diffuse, unfocused space within which buildings are located? At what point does space exist independently, punctuated only by an occasional building? In some modern American urban settings, the idea of space between buildings may no longer make much sense. From the Las Vegas Strip to the typical "edge city" office park, buildings have often become free-floating and unrelated to any spatial context involving other buildings. In such settings, the traditional city made up of buildings with well-defined spaces between them is replaced by a modern city with buildings and spaces largely unrelated and disconnected. In the latter, space dominates urban form, creating little sense of space enclosed by a built environment. I concentrate on the more traditional type of urban setting, but even here the trend since the late nineteenth century has been toward a looser urban form.

The aesthetic impact of a looser city of individual features set adrift in space has been widely criticized for a long time. Alexis de Toqueville suggested that American cities were too lightly developed ever to be maintained properly. This lack of substance and permanence has been a continuing problem. American cities often appear to contain a vast number of unloved and underutilized spaces, even when the buildings nearby are in good repair. Such light development constantly invites the invasion of unwanted uses and creeping dereliction. Other writers and social critics have condemned the apparent

visual and functional chaos and confusion of the new, open city as indicative of a decline in civic virtues and values. For them, increasing spatial separation represents a weakening of the bond that holds communities together. Still others praise the sprawling American landscape as a pragmatic and functional response to the changing technologies of the late twentieth century and a much needed break from romantic idealism and Renaissance aesthetics.

It is not my primary purpose to dwell upon or to directly debate these bigger planning issues, although from time to time I highlight specific design "problems." Rather, I concentrate on particular types of ordinary spaces and how they came to be, what they look like, and how they are used. How and why are they changing? Are we redefining the essence of space in some significant way? How can we better understand the current and historical meanings of the spaces we move through each day? Maybe through understanding the role and importance of small and ordinary spaces we can bring more cogent arguments to the debate on how cities should be organized, designed, and planned.

Organizing Themes

Five themes, embedded in the discussions of real places and features, help to contextualize these observations and tie them to more general concerns shared by students, scholars, observers, and residents of the urban scene. First, and perhaps foremost, I wish to explore just what is meant by "spaces between buildings." In *The Kandy Kolored, Streamline, Tangerine-Flake Baby*, for example, Tom Wolfe suggests that the amazing thing about Las Vegas is that its skyline is made up not of buildings but of big, colorful, free-standing signs. While this gener-

alization is now less true than it once was, the Las Vegas Strip still epitomizes a new, but increasingly prevalent, way of putting American cities together.

The real innovation, however, is not the signs but the spaces. The Las Vegas Strip pioneered the idea of a new kind of city, made up of vast and amorphous spaces punctuated with monumental buildings. The traditional, enclosing city of streets, blocks, and squares was replaced by a city of arbitrary and disconnected individual features. A conventional architectural history of Las Vegas is difficult to imagine because space, not architecture, dominates one's experience and perceptions there. While architecture in Florence, London, or Boston is part of a series of enclosing spatial contexts, in Las Vegas, buildings and spaces are most often unrelated. How this came to be is a long story having to do with the development of the city as a set of individual, competing landmarks, each with the intended purpose of enclosing its occupants in a make-believe environment totally divorced from the world outside. While Las Vegas is not unique in this respect, it has taken the idea further than any other locale. Las Vegas is the model that developers of modern megamalls and office parks emulate when they create vast, self-contained structures isolated in a desert of parking. Thus, while at one time there was often too much "building" and not enough outside space in the typical American city, the reverse may be true today. Especially in many of our newer edge city megastrips, space dominates buildings. Do we need it all? Can we take care of it? How do we use it?

The second theme is a short architectural history of space. For example, I explore the evolution of various facade treatments, stoops, porches, verandahs, sidewalks, lawns, and fences, as it is useful to know at least a little bit about where and why certain types of spaces and enclosures first came to be

widely used. In addition, it is helpful to see how these spaces have changed over time as well as how they have been used differently by different people. In some cases, certain types of spaces may be greatly altered or even eliminated altogether as society changes. In other cases, different generations and different types of people (as defined by ethnicity, class, age, gender) may use in entirely new ways the spaces they have inherited from other cultures or generations. The spaces may look the same, but their meaning and context may have changed. What are the adjustments that people must make? For example, do ideal spaces for the elderly function poorly when used by teenagers, and vice versa? In general, the literature is pretty thin here. There are few books on porches, sidewalks, and the other spaces between buildings, even though we all experience them. We tend to look past space toward architecture, although the places in between are far from empty.

A third theme, closely related to the second, focuses on the roles that codes, zoning, and other governmental requirements have played in shaping the spaces between buildings. While some cities encourage the construction of terraced or row houses, others require that buildings be set apart by a specific number of feet in order to meet fire codes or health regulations. Lot sizes, front yard setbacks, lot coverage limits, off-street parking requirements, wall placement, visibility from the street, street widths, sidewalk placement, and street tree designations are but a few of the landscape features covered by the codes and laws that shape the spaces between buildings. Moreover, zoning regulations increasingly control the types of activities that can go on around buildings and even the types of vehicles that can be parked nearby. Some neighborhoods and cities mandate certain types of vegetation, ranging from open grass lawns to drought-resistant plants. Some locales require

permits to change almost any detail, while others follow more libertarian ideals. By examining how some of these codes evolved and how places vary under different regulations, we can better understand the forces that shape our urban spaces.

Fourth, I consider current worries over the end of public space and the decline of civic culture. Critics of the modern city often allege that it has become excessively privatized and exclusionary. In the traditional compact city, most of the spaces between buildings were public—streets, squares, markets, and the like. Later, grand urban parks, promenades, and boulevards were added to the public urban scene. In recent years, however, an increasing amount of what passes for civic space has turned private. The public courthouse square and Main Street have been replaced by the shopping mall, festival marketplace, or historic waterfront as settings for the social life of the city. In such private, for-profit places, both people and behavior are carefully controlled. Everyone there must be acceptable in appearance and demeanor. In some edge city environments, even the seemingly public streets are really private, and all pedestrians and drivers may be subject to scrutiny and questioning. Most civic, especially political, activities are expressly forbidden in such spaces. People who engage in unwelcome activities are screened out of the mall and have few alternative venues since truly public spaces are often either absent or marginalized.

These concerns bring us back to the ordinary spaces between buildings. The interface between buildings and the spaces adjoining or immediately around them have always constituted a very important dimension of public life. A city with friendly, permeable facades and many street-level doors may well be more conducive to civic life than a city characterized by fortresslike structures with blank walls and invisible doors. Life on the street is, to some extent, defined and guided by the na-

ture of the surrounding buildings. Similarly, a residential neighborhood in which houses have front porches, small lawns or gardens, and plentiful windows and architectural details may present a more walkable and gregarious setting than a neighborhood in which public space is surrounded by walls, three-car garage doors, blank facades, and concrete driveways. The ordinary spaces between buildings (including building facades) are semipublic in that they bestow character and meaning on the public spaces beyond. As architecture changes, space changes. The private-public theme of interaction hinges on the role played by the ordinary spaces between buildings in the quality of civic life.

The fifth, and perhaps most controversial theme, takes up the debate over whether or not there are any universally accepted aesthetic characteristics that cut across all (or most) cultures and define good urban places. Various writers have discussed the idea that biological factors relating to survival influence the kinds of places that people seem to prefer. Landscapes characterized by opportunities for prospect and refuge, some scholars assert, appeal to all cultural groups. Others emphasize the roles that association, communication, and information play in defining the aesthetic landscape. Urban scenes that reference valued cultural icons and local history would seem to be favored over those that exude bland efficiency and universality. Many of the traditional European towns, for example, are replete with statues, fountains, religious icons, and highly decorated building facades. Attempts by graffiti artists to paint murals on the blank, dreary walls of American cities may be a modern variation on the need for place identity and meaning.

Others argue that particular cultures reveal different ideal landscapes and that the search for universal aesthetic charac-

teristics only disappoints. Even possible "universals" within a specific cultural context likely vary over time, especially in contemporary societies in which landscapes are subject to the same trendy whims as art, music, and fashion. Still, as we examine the ordinary spaces between buildings in North America, it may be useful to ponder such things as scale, texture, color, complexity, information, and permeability and to explore the idea that some spaces simply relate to the human senses better than others do. Most people like to feel enclosed, stimulated, and entertained. What kinds of spaces do this best? How do spaces become places?

From Buildings with Spaces to Spaces with Buildings

Ancient cities in China, Mexico, and the Roman Empire often had large, ceremonial open spaces, but they were few in number and were dependent on powerful central authorities. The normal, everyday streets of the city were likely to be narrow and congested. In the typical medieval European city, grand open spaces were relatively rare, because people crowded together for defense, religion, markets, and craft industries. Only gradually did such cities open up as new formal and functional spaces were added. Indeed, the evolution of the Western city over the past thousand years, from its Mediterranean origins to its diffusion on the North American continent, represents a gradual loosening of the urban fabric through the addition of various spaces. By tracing these changes in the urban fabric, one gains some insight into how the modern American city eventually came to be.

To explore the changing character of spaces between buildings, I begin by examining four specific types of urban places, each representing a historical era as much as a geographic setting. These are (1) the Islamic medina, (2) the city shaped by the

Spanish renaissance, (3) the nineteenth-century North American city, and (4) the contemporary North American city. These four examples can be placed along a continuum, from the medieval city, whose built environment was punctuated here and there by open spaces, to the modern American city, whose space is punctuated by occasional buildings. Together, they illustrate the idea that space as much as architecture defines the character of place. While modernization and change continue to take place in all of the contexts described, an examination of the ideal types still extant provides insights into the ways in which human use of space has evolved over time and in different places.

The Islamic Medina

The medina, or the traditional mazelike core found in most of the older Islamic cities in North Africa and Western Asia, is the first city type. It epitomizes medieval urban form: a dendritic pattern of narrow pathways and a nearly solid mass of buildings with little if any space between them. Many of these medinas have changed little over the centuries and serve as living relics of a type of urban landscape no longer observable in other parts of the world. While many North African and Asian cities have Roman origins, the Islamic medieval period represented a "closing of the forum," as former streets and plazas were filled in with buildings or covered to form narrow tunnels or passageways. From above or within, the city appears to be a solid, undifferentiated mass of buildings. Indeed, cities like these are often not perceived as being made up of individual buildings, as it is usually difficult to determine where one building ends and another begins. Ownership and use patterns have often involved invading adjacent space over time, to the point that rooms and courtyards form a labyrinthine internal corri-

dor, discouraging any sense of a city of individual structures. Ownership, access, and usage are governed by Islamic law, and the impact of planning by secular authorities is minimal. Open spaces, except where they have been introduced by European colonial governments, are rare.

In the medina, buildings surround space. Open spaces, which are visible and either public or semipublic, play a minimal role. Rather, the building mass is laced with private interior courtyards, which provide light and air in the seclusion of an inwardly oriented compound. Even the courtyards of the mosques and madrasses (schools and universities) are generally off limits to strangers. The streets or lanes, jammed with makeshift stalls and pedestrians, are usually unsuitable for any form of wheeled vehicle. Busy lanes constitute the majority of the space between buildings, but the idea of a street as a designed amenity is absent. There is a branching gradation of streets from the major (though still narrow) thoroughfares connecting markets and mosques to tiny cul-de-sacs that constitute semiprivate neighborhood space. Along most of these streets there is a continuous blank wall, broken here and there by a colorful door. The buildings seem to have melted together into one amorphous mass with no individual facades or separate and identifiable architectural styles.

Renaissance aesthetics are absent in the medina. The idea of stepping back for a grand vista or sense of perspective was seldom introduced. Even the mosque is often so embedded in the urban fabric that there is little sense of it being a separate entity when viewed from the street. Palaces, too, may be identifiable only by their magnificent doorways. The interface between the private world of the inside and the public world of the outside is minimal and, by Western standards, mysterious. Only the narrow souks and the decorative doors provide zones of inter-

action for observation. Enclosure is everywhere. The Islamic medina is at the opposite end of the spectrum from Las Vegas.

The Spanish City

Beginning with the Renaissance, the medieval Christian cities north of the Mediterranean began to open up. In spite of occasional countervailing movements, such as Venice's decree that all buildings should be built adjacent to one another to avoid unsightly, garbage-strewn fragments of space between them, European cities began to add to the spaces between buildings. In a trend that began in Italy around the start of the fifteenth century and diffused throughout Christian Europe over the following centuries, most cities were gradually transformed and redesigned according to new, more open aesthetic principles.

The most obvious new type of space was the monumental plaza. The Renaissance fostered both a new artistic and a new civic spirit. The artistic spirit led to new architectural achievements and a desire that those achievements be seen in proper perspective. This required broad, straight streets and grand plazas so that the cathedral, palaces, and other important edifices could stand out and be viewed from a distance. The civic spirit required places where the drama of the city could be played out in full—places to gather, meet, and talk.

The *plaza mayor* in Spanish cities provides an excellent example of this new artistic and civic openness. Indeed, many cities, especially those in the south of Spain, were formerly major Islamic cities centered on the medina. In cities such as Cordoba and Toledo, for instance, narrow medieval lanes were gradually opened up with new plazas and visually dominant architecture. The life of the city came to concentrate on the plaza, and grand new buildings with detailed exteriors were

constructed to face it. Similarly, as new streets were cut through, new individual buildings with identifiable facades were built to line them. Well into the twentieth century, most Spanish cities could still be characterized as a solid mass of buildings punctuated by a few significant open spaces and streets. Gradually, however, the interface between buildings and spaces became more varied and detailed. Doors, windows, arcades, balconies, statuary, and various other embellishments were added to the facades in order to facilitate the interaction between buildings and spaces. Much of the visual pleasure of the Spanish city is related to these features.

Although it was far more monumental than anything in the Islamic medina, the *plaza mayor* was still surrounded and enclosed by buildings. In Madrid and Salamanca, for example, grand architectural facades of uniform design were built to surround the *plazas mayor*. These buildings were both monumental and permeable. The arcaded buildings surrounding the plazas have long provided sheltered places for human interaction during any type of weather in conjunction with the civic space. Everything from bullfights and hangings to royal pageantry and markets have taken place in and around the *plazas mayor*.

There are many important characteristics to ponder in the evaluation of plazas as spaces between buildings. How large should a plaza be? How many doors should face it? What mix of economic and cultural activities should there be? Should arcades surround the plaza? How deep should they be? In the traditional Spanish city, the spaces between buildings are few in number, but they are important. Since these spaces are plazas and major streets, their limited number makes the task of observing them manageable.

By the middle years of the nineteenth century, the newer cities of North America were being laid out in a relatively open pattern compared to the tightly packed cities of earlier decades. The newly designed sections of older cities, such as Boston's Back Bay and New York City's Midtown, also included larger spaces between buildings. By the 1880s, most central business districts had wide streets and sidewalks and numerous service alleys. Downtown buildings could thus be viewed from a distance, from across or down the street, and from behind in an alley. In the newly emerging suburban areas, the development of grid-planned streets, the use of several modes of mass transportation, and the eager adoption of essentially rural house types and cottage imagery gradually led to the "garden city" of the later decades of the Victorian Era. While row houses built flush to the street had been common before the Civil War, the invention of the horsecar, streetcar, and lawn mower, as well as increasingly restrictive fire codes, meant that free-standing houses with front lawns were becoming the norm in most cities by 1900.

For perhaps the first time in urban history, vast amounts of public open space abutted vast amounts of private open space on a regular basis as streets, sidewalks, and alleys met lawns, gardens, and storage areas. Nodes of activity like market squares were largely replaced by zones of linear activity. People strolled along the sidewalks lining Main Street and peered through the new plate-glass display windows. Often benches were placed in front of stores and cafes to attract activity to commercial enterprises. People also strolled along suburban streets and interacted casually with those who whiled away the hours on front stoops and porches. Most importantly, the tra-

ditional "street wall" of the city was replaced by obviously separate, individual structures. From the tall buildings downtown to the houses and commercial "strip" businesses in the suburbs, structures were set apart by space.

As the amount of public and private open space increased, new uses were invented to fill it. Many of the urban landscapes that are common to us today took a long time to develop. It took nearly two centuries, for example, for Americans to add front porches to house types inherited from the British Isles. Similarly, stoops, decks, garages, lawns, bird baths, garbage cans, awnings, sidewalks, public benches, and street trees were hardly ubiquitous landscape features until relatively recently. While there is a rich literature on the evolution of suburbia in America, especially concerning house form, the literature on everyday spaces is significantly thinner. It is often necessary to read between the lines—or buildings, in this case.

The Contemporary North American City

By the end of World War II, a new planning ideology was beginning to reshape the American city. As early as the 1920s and 1930s, the traditional city of buildings fronting a grid of streets was being criticized and questioned. Open space was seen as beneficial while the congested city streets were undesirable. The answer, planners argued, was the superblock, a vast sea of open green space devoid of streets and traffic. During the 1930s the idea was tried out in a few public housing projects and garden cities, but the war intervened. The superblock then came into its own during the postwar boom.

Some have termed the new spatial ideology "podding," as it is the creation of pods of activity surrounded by major arterial boulevards. This is in contrast to the gridding of the traditional city. A city of pods is made up of office parks, shopping centers,

apartment and condominium complexes, medical centers, and resortlike hotel and convention facilities. The idea is to separate, often to the point of walling off, land uses into distinctive social and functional worlds. Obviously, these new types of developments call for a complete redefinition of the ordinary spaces between buildings. Typically, buildings in such pods are designed to be set apart in a sea of green lawns and parking lots, with only minimal aesthetic and functional connections to the structures nearby. Many complexes, such as shopping malls, are internally focused so that only the back sides (loading docks and the like) are visible from the street or parking lots. This constitutes a complete reversal of the facadism of the traditional city, in which only the fronts of buildings were visible while the backs were hidden.

While people may experience carefully designed spaces inside a particular mall or office "campus," once outside, everything changes. At the pedestrian level, space often seems vast and amorphous, providing few clues to the route between front door and parked auto. The structures themselves usually have few external space-enhancing embellishments like arcades, patios, or even more than one public doorway. Although there are signs that these designs may be changing as land becomes more expensive and infilling takes place, the overall ambiance outside is often one of isolation and detachment.

Since there is no through traffic in the superblocks, the major streets surrounding the complexes must handle an immense load. The arterials passing between the pods tend to be very wide and busy, making walking a last resort. Even crossing a street can be a time-consuming if not life-threatening adventure. While this is not new information for any student of the city, I do not think we have given adequate attention to how the changing nature of our everyday use of space colors our im-

pression of urban life. Standing on the corner is not like it used to be, and neither is walking. We have replaced a stroll to the corner store with a walk that resembles a hike alongside the track at the Indy 500. It is little wonder that we drive everywhere.

ONE || Buildings and the Spaces around Them

24

Cities are changing. Throughout the world, but especially in North America, the trend is moving away from urban spaces tightly surrounded and defined by buildings and toward the proliferation of free-standing structures lost in space. Increasingly, building ensembles no longer play a role in delimiting and embellishing small and valued spaces; rather, seemingly unrelated structures are situated in vast, amorphous open areas. It was not always so. Until well into the twentieth century, buildings typically provided the decorative "walls" of open space that was also lived-in space. Most plazas, market squares, streets, and walkways were defined and identified by the buildings around them. Important churches, palaces, and government buildings typically were fronted by open spaces designed to enhance their architectural features. The converse was also true: Plazas and squares were architecturally decorated, and important buildings provided character and identity to neighboring open space. Views of nearby buildings provided both aesthetic substance and a recognizable theme for plazas, squares, and boulevards. The relationships were symbiotic. In recent years, these relationships have suffered. While it is clear

that buildings no longer tightly surround space, it is unclear whether most spaces are loosely surrounded by buildings or most buildings are loosely surrounded by space. Either way, *loosely* is the operative word.

One type of open space common to all cities is the street, but street size and morphology have varied tremendously over time, among civilizations, and between specific places. In many of the older cities of Europe, for example, it is still common for streets to be only ten or fifteen feet wide. When tall buildings line such streets, as they do in parts of Genoa, the roadways become dark tunnels and it is impossible to step back and view the architecture. Even when streets are wider, as in New York City, skyscrapers can create the same effect, creating the "canyons" of Manhattan. In such settings, the spaces between buildings seem inadequate. As early as the seventeenth century, cities like Paris and Amsterdam enacted urban design guidelines relating the maximum height of buildings to the width of the street in order to provide adequate air and sunlight at ground level.

In many new developments, however, the problem is just the opposite; there is too little sense of enclosure. It is common to have eight-lane highways with intersections covering an expanse of many thousands of square feet. Unless the surrounding structures are very tall, all sense of an enclosing architecture disappears, as buildings become more and more distant from people traveling on the streets. Parking lots add to the separation, further removing any sense of architectural identity. While the best examples of this phenomenon may be found in "edge cities," such as Tyson's Corner in northern Virginia near Washington., D.C., or Schaumburg outside Chicago, nearly every metropolitan area in North America is experiencing the trend.

The relationship between buildings and space is also affected by the street pattern. Where streets wind continuously and form many T-intersections, vistas are curtailed and views of buildings exist in every direction. The sense of anticipation associated with wondering what is around the next corner also may heighten the role of architecture in giving character to space. People tend to pay attention to buildings. Where streets are long and straight, however, distant views of clouds and sky can diminish the impact of buildings.

Building Facades and the Character of Space

In many of the older cities of Europe and North America, narrow streets predominate and very few open spaces were designed. Because the urban fabric was dense, with buildings normally built adjacent to one another and flush with the street, typically the only part of the structure exposed to view was the purposefully designed facade. Only the parts of buildings that could be seen were beautified; these parts were designed to be part of the overall urban context. The mundane backs and sides of buildings were embedded in a dense urban fabric. Thus, where open space existed, there were usually beautiful surroundings. Most American cities started out with these characteristics, but the pattern did not last.

As American cities began to grow during the latter years of the eighteenth century, terraced or row housing remained the norm for both residential and commercial uses. New York City, Boston, Philadelphia, Baltimore, and other rapidly growing cities borrowed the aesthetic ideals of Georgian London, and well-designed urban places featured uniform rows of buildings punctuated by an occasional park or square. Such landscapes were thought to epitomize the egalitarian, democratic ideals of the new republic. While most buildings were designed to blend

into an overall aesthetic context, important civic or religious structures were built to stand out. These structures were often located on an appropriate open space that they could dominate visually and symbolically. This arrangement meant that cities were aesthetically legible; they made sense. The order evident in the landscape reflected the order idealized by the society.

It is important to recognize that romanticized notions of a beautiful and orderly urban past usually ignore the harsh realities of a time that included cholera, tuberculosis, mud, outdoor privies, horse manure, and heavy labor; nevertheless, a certain architectural harmony was evident. As unbridled industrial capitalism, population growth, economic competition, rapid areal expansion, immigration, and a variety of other massive social changes unfolded during the nineteenth century, however, many of the harmonious landscapes disappeared. One could tell many stories about such scenes, but I focus on the role that ordinary spaces have played in shaping the character of cities. Generally speaking, as the urban pattern loosened with expansion, cities became uglier, in part because unplanned, uncared for open spaces became ubiquitous. Visual order was replaced by what many saw to be visual chaos. There is irony here, considering that much of the criticism leveled at older cities calls attention to their being dense and crowded.

Visual Chaos and the American City

American cities are often described as messy, chaotic, and ugly. Why is it that the typical American city looks so disorderly and strewn together compared to the older urban centers of Europe or Latin America? Much has to do not only with the architecture of individual buildings but also with the types of space that have been created between the buildings. While American cities have always contained an admirable supply of

beautiful civic monuments, business buildings, and houses, their citizens have largely ignored the role that spaces between buildings have played in defining an American aesthetic. Here I define space as more than the open space found in parks, squares, and gardens. I use the term comprehensively to include all kinds of spaces between and immediately around buildings, both at ground level and upper stories. I also include building "skins" in my definition, since space in the city is often defined and given character by the look of the building facades that surround it.

The essential character of the American city is determined in part by the sheer amount of space in relation to the mass of the built environment. To paraphrase Gertrude Stein, in America, there are more *spaces* where nobody is than where anybody is, and that is what makes America what it is. American cities simply have far too much ad hoc, unloved space. This is not a startlingly new observation, but by concentrating on the nature and use of the small, everyday places and spaces that surround urban buildings, we can better understand the experience of living in particular urban environments.

The Aesthetics of Free-Standing Structures

As long as buildings were embedded in Georgian style terraces or commercial rows, only their facades mattered. No one could see the sides or backs of most structures, and, except for an occasional balloonist or church bell-ringer, no one could see the roofs either. Design enthusiasm could be lavished on the fronts of buildings, so beautiful urban edifices could be constructed even with limited funds. While foul and dreary "backyards" existed, the public city consisted largely of pleasant facades. The most ornate facades were constructed around parks, plazas, and squares. Where large public (or semipublic in

the case of private squares) open spaces existed, there was an obligation to face them with beauty and dignity. Clutter was often clandestine. The machinery of living was mostly hidden from view.

Mostly hidden from view, however, does not mean entirely hidden. While many of the disagreeable sides of urban life were confined to inner courtyards, backyards, and cellars, the streets were by no means pristine. Crowds of people and animals as well as periodic markets left reminders of their existence on the landscape. In some cities, pigs were used to "collect" refuse (by eating it), and beggars and ruffians added an additional disorderly dimension to the urban scene. Still, the harmony writ large in the built environment tended to soften the visual impact of messy activities. However, in most American cities, this harmony did not remain intact beyond the early decades of the nineteenth century.

The first modifications of the traditional street-wall aesthetic occurred as individual row houses were either torn down or enlarged. American urban landscapes had no sooner been constructed than the pressures of uneven development began to take their toll. Lacking the strict height and bulk guidelines present in many European cities, American urban places began to bulge and atrophy unevenly as some buildings were enlarged while others were destroyed.

Let us first consider the impact of destroying buildings. By the end of the nineteenth century, most blocks of row buildings had developed many gaping holes. As individual houses burned down or were demolished for open storage space—or, later, parking—the typical American terrace developed a gap-toothed appearance. The vacant lots themselves were often minimally cared for, and blank sides of row houses never meant for public view were now on display. Further, these side

walls were typically much larger than the front walls of structures because the lots were narrow and deep. Rough, unpainted, cracked, and sterile "sides" became visually dominant in many commercial and residential neighborhoods. Sometimes, the exposed sides of these buildings made the lavish facades on the front appear obvious or even ludicrous. In many cases, the fronts of buildings were covered with entirely different materials than the backs or sides. White stucco classical or Italianate facades seemed to hang like masks on the faces of otherwise banal brick boxes. The image of urban open space gradually changed from rare, carefully designed, and harmoniously enclosed to common, unkempt, visually bleak, and occasionally sad.

Obviously, the breaks in the row house blocks exposed backs as well as sides of structures. Often, jerry-built back additions became visible along with the backyard, which was usually a very untidy place. The term *yard* comes from the world of work—shipyard, lumberyard, brickyard—and, true to form, backyards contained outhouses, laundry facilities, trash containers, and piles of building materials. It was anything but a garden. In the early industrial cities of Britain, such yards were often walled, but in American cities, this was rarely the case. So as buildings were removed, the littered landscape of backyards set the aesthetic tone in many neighborhoods.

The backs of houses and businesses became even more visible with the advent of service alleys. Alleys had been uncommon until well into the nineteenth century, but as trash containers, fire escapes, rear exits, and ventilation systems became common or even required, alleys emerged as a behind-the-scenes landscape of the city. Various urban beautification movements during the nineteenth and early twentieth centuries encouraged the removal of service entrances and side-

walk elevators from the fronts of buildings, so back spaces became increasingly cluttered. Also, as buildings became significantly larger, the pedestrian-oriented areas in front could no longer provide sufficient room for massive material deliveries and trash removal. The messy functions moved to the alley, yet alleys were rarely hidden from view. By the turn of the twentieth century, a typical walk in the city brought many vistas of alleys full of unpleasant scenes. The word *alley*, from the French *allée*, or small street, came to be synonymous with the underside of life and was used as a seedy prefix for everything from cats to brawls. Even in quiet residential areas, the alley was a place to burn garbage and throw old mattresses.

Alleys increased the exposure of the backs of buildings just as a highly visible patchwork infrastructure of water pipes, electric wires, heating (and later air-conditioning) equipment, fire escapes, and large trash dumpsters was becoming common. As automobiles and garages were added to the mix, the landscape took on an even more disheveled appearance. By the 1940s, the spaces and vistas provided by back alleys and side lots became the staple settings for film noir thrillers. Parts of buildings that were never meant to be seen were being viewed from unplanned spaces carved randomly out of an earlier city. People started seeing all the wrong things from all the wrong angles.

Dishevelment results from growth as well as from decay, from the impact of building construction as well as destruction. While the number of new, underutilized ground-level spaces was greater in neighborhoods experiencing the removal of buildings, chaotic vistas became common in areas where newer, taller buildings were going up. As land values increased and some property owners tore down older buildings in order to construct bigger office towers, hotels, and department stores, uneven, ragged horizons appeared. Until well into the 1920s,

when a skyscraper aesthetic became firmly established and towers were designed to be stand-alone monuments, most of the taller buildings were constructed in the traditional way— that is, as if buildings of similar size would someday be built next door. In the first two decades of the twentieth century, for example, it was common to see buildings of ten or twelve stories with attractive facades only on one or, for corner buildings, two sides. Thus, the skyline included ugly backs as well as pretty fronts. The character of the spaces between these multistory buildings constituted a very real aesthetic component of the city. Advertisers often used the nondecorated sides of taller buildings for massive signs and logos and, of course, there were fire escapes.

Buildings of uneven height became the norm in the competitive, laissez-faire American city, diminishing the egalitarian harmony of the city's look, but they also brought an additional aesthetic problem. People living and working in buildings that were taller than those nearby found themselves looking down at the roofs of those buildings on a daily basis. In preindustrial cities, rooftops were often charming. A landscape of peaked, tiled roofs and towering chimneys still conforms to many conceptions of picturesque town scenery. But roofs can also be unsightly. The flat or sloping black-tarred roofs of the nineteenth-century American commercial district added little to the aesthetic character of cities. When water tanks, electric wiring, service sheds, and other types of machinery were piled on, rooftops, like alleys, came to epitomize the messy urban scene.

The builders of early skyscrapers sometimes disguised infrastructural elements in decorative towers, a ploy that many contemporary designers have rediscovered. More often, however, building machinery either stood out on the skyline, or it was surrounded by a minimal wall but still open to the sky (and vis-

ible to those in taller buildings). Most rooftops were never meant to be seen and therefore were rarely given careful attention. Today, even in residential areas where the picturesque roofline has held on, the tops of houses are often graced with such unattractive devices as cooling fans, television antennae, and satellite dishes.

The clutter and chaos of the gradually loosening urban fabric taught an important lesson to builders of the American city: Planners could not trust context. They could not rely on the beauty of a facade to carry the day when nearby buildings were likely to be destroyed, enlarged, or rebuilt in a different configuration, leaving a building's rear hanging out or its sides vulnerable and exposed. Architects and designers could no longer assume that adjacent structures would be similar in size and style. In the rapidly changing North American city, if one planned to build, it was best to build a structure that could stand alone. This usually meant empty space between buildings, often in the form of required setbacks. Codes relating to fire, access, and seismic safety also reinforced the trend toward free-standing structures, as did many of the ideals associated with modern architecture and planning. Glass boxes set back in open plazas replaced the traditional wall of buildings in many urban places.

Designing the Five-Sided Building

The new, independent architecture that emerged by the 1950s envisioned a more open city with buildings set in space rather than buildings enclosing space. The design changes required by this major aesthetic transition, however, were not always easy to accomplish. With the front, back, two sides, and roof available for viewing, buildings became subject to aesthetic critique on five "fronts." It has taken a long time to figure

out just how to design new, attractive, five-sided urban buildings. Considering the number of sprawling, minimalist boxes and gull-winged, trapezoidal drive-throughs that dominate our commercial strips, many would argue that we still have a long way to go.

The challenge was a little more manageable in the case of single-family houses, since rural models could be used in the design of the suburban landscape. English Tudor, Spanish, Dutch, and American Colonial houses could be replicated, to a degree, in suburban tracts. There are still problems, however, since clustered, small lots require new kinds of small spaces as boundaries. Fences, walkways, gardens, garages, and driveways disrupt the rural aesthetic. We have never really learned how to design and build a distinctly urban, single-family house. We have simply tried to move the country to the city by using rural house types as well as their associated rustic spaces. We then end up with the country cottage on the lane with the white picket fence in front and the Dutch gambrel-roofed aluminum shed in back.

The design and construction of large buildings in the modern city present a new set of problems related to the massive increase in the number and size of visible walls. Even when the possibility of viewing a building from all four (or five) sides is built into the design, the aesthetic problems are not always easily solved. The cost of designing one exterior wall is simply a lot lower than the cost of designing four, especially if each wall is to be beautiful, symbolic, detailed, and functional in its own right. More often, most of the walls are basically banal. Meanwhile, European cities have tended to avoid the issue by encouraging the tradition of embedding large buildings in the urban fabric and making use of interior courtyard facilities for deliveries and other services. Since these buildings have no

readily visible sides or backs, at least in the city center, many of the aesthetic problems are solved. This arrangement is rare in the United States, where builders have opted for the free-standing box set apart in space.

Some big boxes are harder to design than others. Office buildings, apartment complexes, and hotels can be built as slender towers, using a repetitive pattern of windows for decoration. Windows add complexity and rhythm to the design of a large building while also serving a real purpose. Windows as textural design elements work best when they are individual, identifiable features—the "eyes" of the building. Even when they are part of a flat glass wall, they can at least give the impression of permeability and communication between inside and outside, although some mirrored surfaces make this problematic. Many buildings, however, including some very large ones, have few windows. American cities are full of nearly windowless new malls, supermarkets, department stores, discount outlets, warehouses, schools, sports arenas, post offices, and telephone exchanges that accent the claustrophobic, no-fresh-air look. Occupants are meant to be divorced from the distracting influences of the outside world.

When such buildings are set apart from other structures and surrounded by space, designers often simply run out of money or enthusiasm before much attention is given to the thousands of square feet of blank wall space that is visible to the public. Although there may be a main door that serves to define a symbolic "front," there are sometimes no other obvious differences between the various sides of a building. One side looks very much like another, apart from the major doors or service areas. Blank walls predominate. Unembellished walls suggest little for the design or use of the adjoining spaces, although this can sometimes be overcome with extensive landscaping. More of-

ten, though, a sea of parking prevails. The visual-emotional experience of such settings can be described as anomie and angst. Space can become meaningless when it is not tied successfully to enclosing and interacting architecture.

Even when buildings are set relatively close together, as when new structures are inserted into a traditional city block, the anonymous spaces between buildings enclosed by blank or underdesigned walls can be dreary. This is partly because the continuity of the street experience is disrupted and also because of the lack of attention typically given to what, in a traditional row building context, would be an all-important front facade. When all social and commercial interaction, light, ventilation, and symbolism depended on the front of a building, no effort was spared to embellish it. Building facades were vital in the creation of functional, focused, and recognizable places. With all four sides exposed, however, a project's embellishment becomes a diffuse and expensive task. Although this problem is more apparent when buildings are separated by vast amounts of space, even in denser situations side views can make it difficult to create a visually dominant front that is symbolic of both function and cultural context. At the same time, narrow corridors between buildings add to the supply of bland and anonymous space. Worse yet, such space may even have a subliminal impact, creating a vague, disconcerting feeling among those who do not even remember viewing it.

Symbolism and the Facade

When urban buildings typically were embedded in a dense urban fabric, as they were most everywhere before the twentieth century, the identity, charm, and functional character of a structure was determined by its facade. For a variety of reasons, facades became particularly important in western Europe

by the eighteenth century. Before that time, especially in North Africa and the formerly Islamic parts of southern Europe, it was common to have blank walls facing the street. While decorative doors and tile-work were common, an extreme concern for privacy required that windows and other permeable openings be minimal. This tradition is found in many areas of Spanish America as well. In medieval times, defensible houses were commonplace, even within walled cities, since intraurban feuds could and did break out from time to time. In traditional societies, social status was largely ascriptive, so there was little need to build a residential facade in order to impress neighbors and demonstrate that a family had achieved a position of importance. These traditions began to change as innovations in urban design became intertwined with commercial competition and the rise of an entrepreneurial middle class in western Europe. The design of the facade became more important as new businesses and new community leaders demonstrated their status "out front."

Relatively few specialized commercial buildings faced the streets of the European city until, roughly, the early eighteenth century. Business tended to take place in open market squares or in grand souks rather than in shops. It was usually unnecessary to design facades to entice consumers to enter a building. While a few important structures such as cathedrals and clock towers did stand out, most structures blended into the mass of the city.

By the year 1700, it was becoming common to surround important public spaces with a decorative set of harmoniously sited and lavishly designed buildings. The Place des Vosges in Paris, the Grand Place in Brussels, the *plazas mayor* in Salamanca and Madrid are but a few examples. Beautiful assem-

blages of uniform structures with individual embellishments gave prestige and status to particular urban settings. The facades surrounding the outdoor "living rooms" of Europe were soon designed to the hilt, beautifying the open spaces they surrounded. In time, the new awareness of architectural eras, such as Georgian, Second Empire, and Victorian styles, led to attempts to improve the symmetry or complexity of building fronts. Gradually, these facades became ever more entertaining as towers, balconies, statuary, and porticos were added to the buildings. It was not long before such embellishments spread from the major plazas to the emerging commercial streets nearby. The booming cities of North America emphasized the latter, but there were plenty of public squares as well. From Boston to Savannah in the eastern United States to Santa Fe in the West, elegantly enclosed public spaces brought a sense of dignity and civilization to the new cities of the Western Hemisphere.

The new emphasis on decorative aesthetics coincided with the increasing importance of specialized commercial structures along city streets. As banks, tailors, haberdashers, hatters, lawyers, barber shops, smoke shops, and boot stores all hung out their shingles, building facades came to play an important role in advertising. Banks, for example, often adopted a neoclassical facade with massive stone pillars to imply both strength and permanence. With the advent of plate glass and gas lighting in the early 1800s, window shopping became an important amusement. "Friendly" doors and windows invited would-be customers to enter a place of business. Shop design and window dressing became specialized arts by the end of the nineteenth century. Windows and doors became larger and often constituted the entire street level frontage of buildings. Gradually, indented entryways evolved in order to further max-

imize the area that could be used for display windows and to provide a sheltered alcove where people could linger, get out of the rain, or wait for a trolley. In the meantime, they could peruse the offerings of the shop. On most streets, the only ground-level space between buildings was the highly decorated and permeable zone of interaction around the front door.

In all but the largest cities, few buildings were more than four or five stories tall until well into the twentieth century. Between the first floor and the roofline cornices, decoration and embellishment were largely provided by the design and rhythm of windows and their accouterments (lintels and eyebrows). Since the majority of light and air came in through front windows, they were indispensable and universal. No matter what the building's function, it had windows. They could be gothic in shape, have Italianate lintels or French-inspired shutters, and could have a variety of curtains. Hundreds of windows provided a friendly, decorative pattern resembling eyes on the street in nearly every section of the city, commercial and residential. At night, the lights from inside cast a warm glow over the streets below. Perhaps Amsterdam, with its tall, narrow houses and big windows, best epitomizes this aesthetic, but it can still be found throughout the older sections of many cities in North America, among them Boston, Baltimore, and Charleston.

With the adoption of electric lights and artificial ventilation and heating during the early decades of the twentieth century, the need for windows diminished. Windows remained desirable if not essential in most office buildings and hotels, but department stores and warehouses often covered them in order to create more internal wall space. Aesthetic tastes changed as well. By the 1950s, formerly window-filled buildings along the main streets of American towns and cities became overlaid with a variety of "modern" plastic-metallic facades, along with

large signs depicting some very un-Main-Street-like scenes, such as a neon palm tree cocktail lounge. Quite apart from any lapses in taste evident in these modernizations, the dearth of windows tended to make streets less friendly and permeable, instead becoming more anonymous. By the 1970s, massive windowless schools and office buildings were being mandated in many communities, often in the name of energy efficiency. The aesthetic change brought on by the trend toward divorcing buildings from their outdoor environment is akin to the shock of going into work or school on a sunny morning and coming out in the wake of a blizzard.

Creating Places in Front of Buildings

There is more to the way buildings relate to the spaces around them than their windows, textures, signage, and other decorations. Beyond the "skins" of buildings are various and sundry protrusions, which serve to create an intermediate zone between buildings and the street. Such embellishments are the special places that constitute the boundary zone between inside and outside. Without them, the transition between the two can be abrupt and uncivil.

Steps add another dimension to the ways in which buildings interface with the street. Stairways and steps were a practical necessity when streets were muddy and unpaved. People who could afford it lived above the grit and grime of the outside world. In many cities, the threat of flooding was real, and living space was built as far above ground as possible. In cities less prone to flooding, storage cellars and servants' quarters could be built at least partly below the level of the street, with the nicer living spaces slightly above. Sometimes basements or cellars had separate entrances with steps down to them, while the main floors featured more substantial and elegant stairways

leading upward. Decorative posts, Greek columns, and wrought-iron railings were often used to beautify outdoor steps, but sometimes, as demonstrated by the white marble stoops of Baltimore and Philadelphia, the plain step itself was beautiful and functional.

During the late eighteenth century, steps became an important example of the lively and symbolic role that good spaces around buildings can play in cities. They provided a vital intermediate semiprivate / semipublic space that was both part of the building and part of the street. In the general absence of benches and other types of street furniture in American cities, steps provided places to sit and chat with neighbors or to cool off in the evening while watching the world go by. Potted plants and other personal decorations of space were placed upon them, and new games such as step ball evolved around them. While few American cities had settings that could match the grandeur of, say, the Spanish Steps in Rome, ordinary steps and stairways provided animated nooks and crannies in many urban neighborhoods. As long as row houses built flush with the street predominated, there were few other options. Buildings interacted with the world beyond through doors, windows, and steps. The traditional "street as an extension of the house" with steps as chair and gaming table, became a standard feature of residential settings.

As houses became larger and set further back from the street, steps sometimes grew into grand staircases. This was especially true where first floors were built higher off the ground to accommodate basement dwellings. As traffic increased and as distance from the street became more desirable, steps provided residents a sense of separation. Having steps to climb meant that one could look down on the street and enjoy a little privacy from passing strangers even when the curtains were

open. Steps provided an important intermediate space between house and street that was later reinforced by the front porch or verandah.

The front porch was perhaps the first major facade embellishment that affected the way American buildings interacted with the space around them. More than any other innovation, the porch created a social world between the structure and the street. Front porches figure large in history and literature as an exceptionally important type of setting for a variety of social activities. Courting on the front porch swing became a staple cliché in American films by the early decades of the twentieth century. It was on the porch that Andy Hardy, sipping lemonade, usually suggested "Let's put on a show." Songs were sung and plans were made on the porch, a place that was part of the formal house yet a little apart from it. It was a place of relative freedom, an intermediate zone between the building and the street. In recent years, the porch has become an important nostalgic icon for those advocating neotraditional design. It can add not only a transitional space but also visual complexity to the front of a building, with a collage of romantic historical references.

The American front porch is a hybrid with many distant and varied ancestors, including the European covered street and the tropical verandah. One of its forerunners was the arcaded street. By the late Middle Ages, many cities in northern Italy and the alpine areas of France and Switzerland featured a variety of continuous arcaded streets. Arcades allowed buildings to be greatly enlarged by using the space over the public street. Thus, streets became narrower in exchange for the creation of a covered pedestrian walkway. As space in cities became more expensive, the construction of arcaded streets facilitated the construction of larger buildings while also creating marketable

prestige locations for covered, protected shopping. By the eighteenth century, the arcaded street had become an important element in urban design from Paris to Bologna. In Spain, many of the new *plazas mayor*, inspired by the arcaded piazzas and loggias of Italy, were built with arcades. The practice quickly spread to the new colonial cities of the Caribbean and to Spanish South America. Arcaded streets added a sense of permeability to the street scene, especially in Mediterranean cities, where fortress houses had long been the norm.

In warmer climates, cafe owners and merchandisers often took over the semipublic space in the arcade and benefited from the combination of comfort and visibility found there. In cold or rainy weather, pedestrians enjoyed protection from the elements plus a sense of participation in the activities going on both inside and outside the arcaded structures. Passers-by could see into buildings through display windows, while the warm glow and sweet smells emanating from the shops and cafes permeated the partly enclosed pedestrian ways.

In North America, where there had been an early separation of commercial and residential activities, commercial buildings were rarely part of true arcaded streets. In a land characterized by unbridled individualism and competition, the degree of cooperation required for a continuous row of arcades could not be achieved. By the turn of the twentieth century, however, the temporary awnings that shaded many commercial streets were gradually metamorphosing into something more monumental and permanent. Great illuminated overhangs gradually came to define the space around front doors of major buildings. The movie marquee is the most notable of this type of overhang, but many stores and offices followed suit. When this shelter was combined with an indented facade of display windows and an open foyer, the arcade effect was at least partly accom-

plished. As electrical lighting became more powerful and sophisticated, entryway "territories" could be defined both by light and by architectural features. Brightly illuminated zones around doorways could define space and give it character. The "Great White Ways" of the city were soon important spaces for window shopping as well as entertainment. In recent years, a few individual American buildings have included true arcades in their facades, but these usually end at the property line.

In addition to the arcade, there have been several other antecedents for the American front porch. A wide variety of verandahs (the term comes from Hindi) or porches have long characterized the tropical regions of the world as obvious responses to the need for living space that could be open and well-ventilated yet still protected from sun and rain. The idea of a front porch as a formal residential design element entered North America sometime in the middle of the eighteenth century, imported from the Caribbean, where it had evolved as an important element in the local vernacular traditions of both French and English colonies. It enabled the owners of sugar plantations to sit in the shady breeze and oversee operations. Porches or portales also existed in Spanish colonies, although upstairs balconies vied with them in importance.

At first the porch was a rural phenomenon. It was easier to attach one to a mansion, as George Washington did at Mount Vernon in 1777, than to an urban house on a narrow street. As the nineteenth century approached, however, the urban invasion was under way. The first widespread use of functional and decorative porches in a North American city was most likely in Charleston, South Carolina. Like most Anglo-influenced cities that boomed during the last decades of the eighteenth century, Charleston was dominated by multistory brick, Georgian style

houses. The houses were suited for the climates of England and Massachusetts but proved stuffy in the subtropical South.

At first, porches were added, usually on two or sometimes three levels, to the sides of the houses to exploit the winds coming off the bay. Also, since the houses were narrow and deep, more rooms would have access to a side porch than to one in front. The street frontage of most houses remained Georgian or Federal in appearance, but porch additions on their sides gave them a more exotic look. On houses close to the street, formal front doors usually provided access first to the side porch, which served as a sort of outside foyer for the house proper. The side porch never caught on elsewhere, and this unique architectural feature remains one of the charming aspects of Charleston. By the early nineteenth century, higher land values and smaller street frontages in Charleston encouraged the construction of simpler front porches facing the street.

The balconies of New Orleans, often wrought-iron additions to basic Spanish style brick houses, and the portales of Santa Fe, New Mexico, are two of the other sources for the American front porch. Many rural house types, such as the pyramidal-roofed bungalow common in the coastal southeast, also served to introduce the porch to the American scene. For a long time, however, porches were confined to the American South. Tiny entryway porticos seemed to be more than enough for the North.

Nevertheless, the front porch became the norm throughout the eastern parts of North America by the mid-ninteenth century. The popularity of the Greek Revival style in the 1820s helped to quicken the acceptance the front porch, since the image of the ideal house gradually shifted toward a view of house

as temple, with gable toward the street and a massive Doric or Corinthian-columned portico. The front porch was suitable for all kinds of buildings, from row houses, assuming there was at least a small street setback, to those homes with enough room for a wraparound verandah enclosing three or even four sides. Gradually, specialized porch furniture and decorations also evolved, helping to make the porch a unique kind of social place. As work weeks got shorter and leisure time increased, the porch became an important center for recreation. In addition, new uses were popularized as sun porches, sleeping porches, and breakfast porches joined the ranks. Occasionally porches were built at street level, but most often they were combined with steps to create a grand, symbolic yet supremely functional entrance for even humble abodes. This, after all, was the original Greco-Roman idea.

As late as 1952, in an article in *House and Garden*, it was argued that "the front porch is an American institution of high civic and moral value. It is a sign that the people who sit on it are ready and willing to share the community life of their block with their neighbors." Nevertheless, the porch has all but disappeared in recent decades. The combination of air conditioning, television, telephones, vehicular street traffic, the front garage, higher construction and land costs, and a decline in neighborhood socializing have all spelled trouble for the front porch. As a result, many neighborhoods seem cold, impersonal, and impermeable. The interaction zone is gone and houses seem more self-contained. Friendly windows and complex porch configurations have been replaced by blank garage doors.

There has, however, been a reaction to this trend. Many neo-traditional developments have begun requiring front porches once again in the hopes that, if you build them, people will sit. The jury is still out. Why sit on a porch when you can drive to

the mall? Why converse with a next-door neighbor when you can watch a video in the den? Indeed, in many neighborhoods, the trend is going in the opposite direction—toward high walls and fences. Such houses offer refuge but not prospect. You can hide but you cannot watch; like cats in a tree, human beings usually like to do both.

Fences, Walls, and Gates

In many ancient cities, where a defensible site was of primary importance, city walls and the walls of buildings sometimes merged imperceptibly into one and the same thing. Buildings on the edge of town featured thick walls facing outward toward the countryside. Even within the city, fortified houses often predominated, so blank walls were common at street level. Internal courtyards provided light and airy settings for outdoor activities. Long after the need for defense had disappeared, the walled courtyard remained a basic house type and a cultural ideal in Iberia and other parts of the Mediterranean region. The form diffused to the Americas, where it sometimes merged with and reinforced local traditions. Courtyards surrounded by fairly high walls constitute an important dimension of what North Americans think of as Spanish architecture. Elaborate walls and gates are common elements in Spanish-influenced Mexican residential areas, even when they do not enclose courtyards. As an archaic but important landscape feature, colorful walls and fences can be found on both sides of the United States–Mexican border.

The aesthetic of the wall was far less common in the Anglo-American city. In larger cities, where houses abutted the street or sidewalk, the permeable window and stoop pattern described above prevailed and there was no room for a separate wall or fence. In the smaller towns and suburban areas of nine-

teenth-century North America, however, where houses were set back from the street and occupied only a portion of the lot, fences were common. Most often they were low, see-through white picket or wrought-iron fences, which did not interfere with the visual dominance of the house. They did not so much enclose space as delineate it, creating neat edges for gardens. They were also functional, keeping domestic animals in the yard and keeping out potentially troublesome creatures like stray pigs, goats, or dogs.

The picturesque and transparent fence reinforces the "country cottage" aesthetic with its references to fenced farmyards and the like. Where such fences still exist in urban residential areas, they often exude rusticity. Replicas of log or rail fences are other charming property demarcations that compete with the white picket fence. Only in more problematic areas—"big dog zones"—are modern materials such as chain link, barbed wire, or concrete and cinderblock fencing used, and usually only after all aesthetic pretenses have been dropped. In almost every kind of urban residential area, high, impermeable fences of stone or wood are considered unneighborly. High fences were often thought to make it difficult to police areas, because officers in cruising patrol cars could not easily spot suspicious activity. The fear of "criminals in the courtyards" led to the philosophy that houses should be more openly visible.

The planners and builders of North American cities and suburbs have never really come to an agreement on the role that fences and walls should play in neighborhood design; a wide variety of codes and restrictions have affected their use. Many municipalities have outlawed any kind of fencing in front of buildings in order to encourage the aesthetic of an open, sweeping lawn. By the early years of the twentieth century, the look of unencumbered grass lawns associated with the English

landed gentry and their grazing sheep was often mandated, especially in more fashionable suburban areas such as Riverside, Illinois, or Grosse Pointe Shores, Michigan. Even in modest residential areas, there was a widespread feeling that fence builders could not be trusted to do the right thing. After all, a variety of fencing styles, materials, and heights distributed somewhat randomly through a neighborhood would add considerably to the clutter of the landscape. Relatively uniform fencing for the length of the street, such as the wrought-iron fences found in some older townhouse neighborhoods, was not often seen as a suburban option either. Better to have no fences at all.

While many such codes and restrictions still exist, the situation has changed a bit in recent years. As lots have gotten smaller and houses have gotten bigger in most residential areas, aspirations for an estate or ranch have diminished in favor of more intimate and highly decorated front yards. In extreme cases, lot coverage is so high that there is a desire to capture every inch of outside space for intensive use. Where there are required setbacks, as in most areas, this means patios are often built out front. When chairs and tables appear, walls are likely to follow. In high-density neighborhoods, the "wasted" space of a sweeping front lawn is increasingly being reclaimed as codes and restrictions are relaxed accordingly.

Hedges and other types of vegetative "walls" have served as transitional elements in some neighborhoods not quite ready to accept solid fences. Hedgerows, flower gardens, and a variety of small trees, bushes, and even cacti have served to demarcate front yards in many American settings. In other areas, especially commercial districts, earthen mounds, potted plants, bollards, brick or stone paving material, and even signs have been used to define and embellish front entry zones.

Traffic has had an impact on our willingness to create walled enclosures. During the heyday of the commercial strip, from the 1920s to the 1960s, most major urban arterials were lined with businesses. But that is no longer universally true. As huge residential "pods" surrounded by major through streets have become standard, housing complexes walled off from noise and pollution have gained acceptability. High brick or concrete fences make for a citadel appearance very different from the inviting landscapes of Norman Rockwell nostalgia. In such fortified neighborhoods, however, the houses actually front the smaller internal streets, so while these "back fences" have served to give walls a kind of acceptability, they have not impacted the house facades.

Recognizable Territories and Defensible Space

The practice of creating highly visible and precisely delimited territories in front of dwellings and other structures may be more universal than is often assumed. Folk housing throughout the world exhibits the combination of territorial gradation and casual surveillance that has been described by Oscar Newman as "defensible space." For space to be defensible, there should be at least four clearly defined levels of territory separating impersonal main thoroughfares from a personal dwelling or business. The ideal sequence is public space, semipublic space, semiprivate space, and private space. Going from the first to the second level can be the transition from a busy public street to a side street recognized as part of a community. The third level of territory, semiprivate space, is that space around and between buildings. The steps, hedges, picket fences, porches, walkways, indented commercial entryways, planters, and textured sidewalks described above constitute important territory between the private front door and the public

arena. It is here that the private world can merge gradually with the less-defined and less-controlled spaces increasingly farther away. Social and psychological problems leading to anomie and crime are likely to rise when the private front door leads directly to undefined public space with no intermediate nooks and crannies between, since the ability of residents to claim and enjoy territory is constrained.

The spaces around buildings work best when there are either real or symbolic "gates" leading into personal but highly visible microterritories. Such spaces are visually part of the community, even though most of them are privately owned and the gates are usually more symbolic and penetrable than real and locked. Classic examples include decorative pillars beside steps or ivy-covered archways in a picket fence. These are Western versions of the torii gates of Japan; unmistakable signs that one has entered a special, watched-over place. While one gate is usually enough, two or more gates may be designed to work together. If the gates are too numerous or formidable, however, the place may cease to be pleasing and start to look like a prison camp. The trick is to make space both aesthetic and defensible using subtle, culturally acceptable design elements.

In order to be defensible, space should be easily monitored or watched, preferably in the course of everyday living. At the most obvious level, people sitting on a front porch or in front of a kitchen window can watch over the intervening turf between the public street and private door without any special effort. The proprietor of the traditional corner store may do the same thing as he or she watches the street and the comings and goings of potential customers. More recently, closed-circuit video cameras and security guards have sometimes replaced casual surveillance with purposeful surveillance. However, this, like

the formidable locked gate, drastically changes the character of space. Friendly observation is replaced by policing.

Good defensible space has both territorial gradation and casual surveillance; there must be both a sense of controllable territory to watch over and someone to watch over it. Ideally, such space should also be malleable and amenable to personalization by occupants. Policies should allow residents to make small changes in decoration or in the spatial arrangement of furniture or plants. If spaces consist of hard materials where design is literally written in stone, the human touch associated with arranging and rearranging may be hard to accomplish. Good space is fragile too. Unbreakable, impersonal, institutional landscapes designed to be unmodifiable often bring out the worst behavior in people, as they are challenged to make recognizable places through graffiti or vandalism.

The final requisite for defensible space is harder for an individual building owner or occupant to design. If the setting or location of a structure is undeniably awful, little can be done to create a pleasant set of spaces nearby. Fortunately, few locations are truly awful, although being under a freeway ramp or next to a rowdy bar may present special challenges to even the most creative designer.

Commercial "Invasions" of the Space around Buildings

So far I have moved outward from the facades of buildings to include discussions of the spaces immediately beyond, which act as buffers between the inside and outside worlds. There are other types of spaces to consider, especially in commercial districts, where special-purpose activity zones have evolved to enhance and support the functions of adjacent buildings.

The activities that occur within buildings have, on occasion, spilled out into the street. Medieval shops, for example, often

had Dutch doors that could be tipped and used as display tables for customers standing outside. Today, throughout Europe, North Africa, and Latin America, goods are regularly displayed in piles, stacks, or racks on the streets or sidewalks in front of shops. Such invasions of the public domain have always been far less common in the United States, where interior spaces typically have been more generous and the climate more extreme. Still, many stores and restaurants do occasionally use outside spaces to good effect. Newspaper stands, independent bookstores, fruit and vegetable markets, used clothing emporia, flower shops, and cafes are among those establishments most likely to claim the space between buildings for at least part of the day. As a result, there are often complicated disputes over just how many rights businesses have to use the public streets or sidewalks nearby. Permits and licenses must be obtained even for rolling pretzel stands, often over the objections of indoor competitors who must pay rent and property taxes. While most displays are set up anew each day and removed at night, some commercial overflow results in permanent or semipermanent takeovers of public space. In New York City, for example, several restaurants on Columbus Avenue have extended glass "porches" that cover much of the sidewalk. While pedestrian flow may well be impeded, the glass walls, bright lights, and lively ambiance of the extensions help to make the avenue a place.

The use of outside space on streets that have large numbers of small shops, many doors, and a great deal of overflow activity contrasts markedly with the lifeless outdoor scene on most urban arterials. Even where sidewalks are wide, blank walls with few doors or windows can make the adjoining space uninviting. Nevertheless, during the 1950s and 1960s, the trend was toward blank walls with few doors.

BUILDINGS AND THE SPACES AROUND THEM

In a sixteen-square-block area in downtown San Diego, for example, there were more than 1,500 street-level doors in 1927, but by 1970 there were fewer than 400, and many of those led to parking garages. Until the mid-1980s, the San Diego street scene was made even less active by a variety of codes that disallowed almost every kind of commercial activity on the sidewalks around doorways, including sidewalk cafes. With few doors and no spillover activity, the spaces around buildings were usually empty. Over the past ten years, the codes have been relaxed and on the few streets where small shops and many doors remain, sidewalk spillover has boomed. Permits allowing the use of public space have been easy to obtain (although the regulations have sometimes been controversial), and there are now more than seventy sidewalk cafes in the core of downtown San Diego. Most of these have small wrought-iron fences, potted plants, special lighting fixtures, and other features aimed at dressing up the street and establishing a recognized outside territory. While things are generally looking up for the fronts of urban buildings, their backs and sides have not always participated in the new enthusiasm for urbane design.

A Closer Look at the Sides and Backs of Buildings

The increasing visual and physical accessibility of the sides and backs of buildings, which is especially pronounced in but not unique to North America, has been a mixed blessing. On the good side, congestion and chaos associated with garbage cans, trash piles, and deliveries have now largely moved to the rears or sides of structures so that the front facades can emphasize the pleasures of urban life (or sterile efficiency). The world of consumption now can be divorced completely from the work that supports it.

This means that the less visible spaces, usually to the rear, are free to become specialized zones where loading docks, huge trash dumpsters, exposed wiring and plumbing, ramshackle additions and the like are often put—out of sight, out of mind. When there is enough space, parking in the rear is provided. The backsides of older buildings are also often decorated with required rear exits, fire escapes, working porches where laundry was once hung, and cellar doors. More recently, iron grills and other blatantly defensive features have appeared over windows, especially those in alleys. Newer buildings are more likely to have simple blank walls; less ugly, perhaps, but certainly not pretty. Only rarely have there been many attempts at aesthetic improvement on the backsides of buildings. The sides of buildings too can be dreary and unaesthetic, especially where uneven development has led to great gray walls looming over adjacent modest structures. The visual effect can be jarring, as when the roofline of a Victorian house is silhouetted against a ten-story concrete slab. The greater visibility of building sides, however, has led to some interesting attempts to soften their impact.

A technique often used these days to soften the impact of massive walls is the application of vivid color. By painting different sections of a building various, boldly contrasting colors, its mass can be effectively fragmented so that it appears to be several smaller structures. At best, contrasting colors can be used in combination with faux windows and a variety of paste-on pillars and protuberances to give walls a complex and variegated look, which can downplay their size. At worst, bright colors may simply distract viewers and give them cause to ponder the taste of the painters rather than the volume of the structure. The odd shapes and playful rooflines of many contemporary buildings also serve to minimize the visual impact of huge

structures. Normally, however, the aesthetic solutions are more blatantly commercial.

Massive side walls have often been used for advertising. Huge ads were painted on the sides of buildings as early as the mid-nineteenth century, but the emergence of the truly tall, blank side wall brought new possibilities to the pushers of products. While the ads persist, the new trend is toward mural art and trompe l'oiel. In many cities, realistic "windows" have been painted onto the sides of buildings to increase the visual interest and create the illusion of permeability on these formerly gray monoliths. In some settings, artistic murals depicting the local sense of place have been encouraged. In Portland, Oregon, for example, scenes of snow-capped Mount Hood and rivers and forests have been painted on many buildings. Historic murals featuring pioneers and other important local personages also are common. Cavorting whales are now a pervasive urban wall theme from San Diego to Atlanta thanks to the traveling muralist Wyland. The use of ads, murals, and simple patterns of bright colors has gradually spread to the backs of buildings as well. As the urban fabric has been torn away from many older structures, they have become canvases for urban art. Generally speaking, the better and more local the art, the less likely it is that unauthorized graffiti will appear. Graffiti often simply fills a vacuum.

In both commercial and residential areas, exposed walls are sometimes decorated with "ethnic" or community symbols. Black-, Latino-, or Asian-themed murals have appeared on the walls of apartment complexes, public housing projects, grocery stores, and even bridge supports. Many of these have been authorized and encouraged by city governments in efforts to instill community pride. Where exteriors of buildings have been personalized by the community through art, the spaces

nearby often become real places for social interaction even when they are ragged and formless.

Mural art began in the barrios and ghettos of American cities. It is fascinating to see how it has moved to mainstream, downtown structures. Blank walls everywhere invite embellishment. In many instances, the line between mural art and advertising has become blurred. As the number of billboards has decreased, some advertisers have turned to mural-like art on the sides of buildings. Special events such as the America's Cup sailing race in San Diego or the Olympics in Atlanta have also been portrayed. Most of these displays occur in commercial districts. In residential areas, there have been other issues to face.

Walls, Walks, and Windows in the Spaces between Houses

Windows are an important design element in suburban neighborhoods with single-family homes as well as in more traditionally urban settings. One of the biggest differences between older neighborhoods and those of the newer tract developments is that the former tend to have large, "friendly" windows, usually with romantic trim, while the latter have small, squinty aluminum ones. Windows play second fiddle to garage doors in most newer areas. As a result, the two types of places often have very different personalities. These differences are related to a number of factors, among which are codes that seek to minimize window size in the name of energy conservation and an increasing fear of crime. The newer parts of our cities are less gregarious in appearance, especially in the absence of related features such as porches.

While the style and positioning of windows, porches, and walkways where houses face the street merit the most design creativity, the almost universal popularity of the free-standing,

single family home means that the sides of houses, and the space between homes, also deserve some attention. During the last decades of the nineteenth century, free-standing houses gradually became the most popular type in most North American cities. While row houses remain common in cities like Baltimore and San Francisco, even there most suburban developments feature separate houses. As this trend accelerated, new design issues arose. Thick walls could provide privacy between row houses; even when some noise could be heard, there was no visual contact between dwellings. Thin walls, typically wooden, and a few feet of space often meant less privacy, especially if there were side windows, doors, and walkways. As more houses were built as separate units and side setbacks were required to meet fire and other codes, questions arose concerning the nature of the intervening spaces. Should there be windows? Should windows be carefully positioned so as to avoid mutual gazing? Was it possible or even desirable to design houses that would avoid bedroom-to-bedroom views? Could annoying "noise canyons" between multistory buildings be avoided? How far apart should structures be? Most importantly, what kinds of activities should be encouraged or discouraged in the space between such buildings? Sometimes a little space can be worse than no space at all when it comes to noise and privacy.

An almost universal use for the new side spaces between houses was a walkway, so that access to the backyard could be accomplished without going through the house. Moving garbage cans, gardening equipment, and the like became a much simpler task with this innovation. Children could visit the yards of playmates without tromping through the front room, and bicycles could be wheeled to the rear of the house for safekeeping. The backyard gradually emerged as a recre-

ational space rather than a storage area as physical and visual access to it improved with side walkways. Alley access alone had not been conducive to this change. But what activities should take place in the side spaces themselves? Could smelly trash cans be stored there? Could loud and boisterous play or work be allowed? Should walls or hedges be used to define an already small and congested area? Should gates limit access to the backyard, where valuable toys or tools might be left lying about?

In some neighborhoods, side porches and side doors appeared. Such additions often had to face the same way, to avoid porch-to-porch views separated by only a few feet. Similarly, side doors could be annoying if used late at night directly below the windows of a neighbor. For a brief time, peaking in the 1930s, driveways were constructed in sideyards, sometimes leading to a garage located behind the house. As long as cars were few in number and used rarely, this arrangement worked pretty well, but by the 1950s, problems arose. Sideyards became parking lots, and noisy engines directly outside neighbors' windows could make for strained relationships. Civility had to be restored. The solution was to move the garage forward and shorten the driveway.

In recent years, it has become common to use a double-car garage as a buffer between houses. If the garage is built on the same side of all the houses in a given row, the windows of one house can always face the blank walls of a neighbor's garage. The resulting pattern can result in both privacy and anonymity. Spaces for casual interaction with neighbors can be minimal. Blank garage doors dominate the street and blank garage walls face the neighbors. To the extent that it still exists in the busy, modern world, neighborhood social activity has moved to the privacy of the backyard.

BUILDINGS AND THE SPACES AROUND THEM

The Great Transformation of the Residential Backyard

In most neighborhoods, the ritual of pedestrians stopping to chat in front of a neighbor's porch or stoop has been replaced by electronic garage door openers, which allow drivers to avoid ever setting foot in front of their houses. If anyone has time to while away the hours, they do it in back, away from the impersonal street. The backyard has developed to accommodate much of the activity that once took place in front of houses.

For a long time, the backyard was primarily a place for productive activity, not so much for recreation. A basic issue here is determining the relative size of front yards and backyards; that is, where to put the house on the lot. Throughout the early decades of the twentieth century, the suburban ideal required a reasonably large front yard, which was dominated by the picturesque facade of the house. The backyard contained the garage, clothes lines, gardens, tool sheds, and the like. Moving the garage to the side or front of the house freed the back for recreation, but there was still the matter of the front yard. In recent years, it has gradually diminished in size and symbolic importance as the house has been moved forward on the lot. In many newer planned unit developments, neighborhood associations are responsible for all front yard maintenance, allowing residents to focus all of their creative talents on the backyard. Once-familiar front yard recreational accouterments such as basketball hoops on garages are becoming rarer and often are disallowed by codes, covenants, and restrictions.

For the past four or five decades, backyards have been used primarily for periodic recreation. The occasional picnic, croquet tournament, game of catch, or Easter egg hunt could all be found in the backyard. A "yard" was fine for these types of activities, but as recreation became the normal use for the

spaces behind houses, new forms, features, and names were introduced. California, with its emphasis on outdoor living, has been a major source area for these innovations.

Beginning with a tentative boom in the 1950s, the patio, a space for dining or recreation adjacent to a house or apartment, has become increasingly popular. Derived from Spanish courtyards and California variations on the theme, the patio utilizes solid walls of material or vegetation to create a cozy, well-defined space with a sense of enclosure and privacy. Since walls and fences have always been more acceptable in backyards, where dogs are corralled and work spaces need screening, small yards can sometimes be converted to patios with a minimum of effort. Patios typically have tiled, concrete, or stone floors, and so they make ideal outside spaces for apartment units on the second or third floor of a building. The patio model of outside space has replaced the balcony model in many midrise developments.

The enclosed nature of the patio, however, makes it less appropriate in regions where open, minimally fenced lawns are typical. Here the popularity of the deck has exploded in recent years. The term *deck* has had a circuitous trip from its nautical origins to its present use, denoting an outside setting for a hot tub, barbeque grill, and a few lawn chairs. As a part of the American suburban backyard, decks evolved in California and other topographically challenging locales where houses were often perched over precarious precipices. Wooden decks were built over steeply sloping backyards in order to create usable outside space in the absence of the usual flat lawn or patio. The idea has gradually caught on even in those places where backyards are flat. Most modern houses lack back porches, and so decks, which can be added relatively easily to almost any architectural context, have taken on some of its traditional functions

as well as several new ones. Most decks do not have covers, but chairs, tables, plants, hot tubs and the like can be placed on them and remain above the wet and sometimes muddy yard. Decks can be swept or, in snowy climes, shoveled, offering at least a little protection from the vagaries of nature. They also may contain several levels, to allow for a variety of possible sun angles or breezes. Decks provide a functional and cozy focal point or *place* for a plethora of backyard activities.

Patios and decks are multipurpose activity zones designed to extend living space beyond the house. Over the past decade or so, they have been used increasingly in commercial areas to accomplish the same end. It is now common to see bars, cafes, restaurants, and even bookstores add space by extending a wooden deck or cozy patio out toward the once dreaded alley. These "new" features have space-invading capabilities. It can be acceptable to locate tables and chairs out back even if there is unsightly exposed plumbing and wiring *if* you have a deck— just as it is acceptable to dine on the sidewalk *if* you have the proper fixtures for a sidewalk cafe. Often, it does not take much to make the spaces between buildings attractive and usable.

In addition to patios and decks, backyards are now filled with a variety of more specialized features, chief among them the swimming pool. In warmer states from Florida to Arizona and California, pools fill the backyards of many neighborhoods. Even when actual swimming is rare, pools delimit space and provide a focused amenity in much the same way that well-designed patios and decks do. They help to create a sense of place. For safety as well as privacy, access to yards with pools must be limited, so high walls or fences are required. Pools also require relatively high levels of maintenance, further keeping the owners away from the front of their house.

Turning the City Inside Out

It has taken a long time for the spaces around and between buildings to evolve. Many of them have kept their original functions and appearance, while others have changed dramatically. For example, many houses and commercial buildings now have front facades that are symbolic rather than functional. In settings with minimal pedestrian activity and parking at the rear of buildings, the front door may seldom be used. On a snowy winter trip to Ohio in 1998, I observed several townhouse developments that included all of the symbolic features commonly associated with front facades and proper front doors. They boasted magnificent Georgian style doorways with numerous colonial embellishments, but these front doors were never used. These were planned unit developments with group parking in the rear, and the front doors faced busy streets with no sidewalks. There were no footprints in the snow anywhere, and no one had bothered to shovel the front walks several days after a heavy snowstorm. The front doors were now the back doors, yet form did not follow function. The confusion was jarring, and the design was insincere.

There are many other examples of such reversals, but nowhere are they more exaggerated than in the modern shopping mall. In many communities, the malls' walkways have become the streets of the city, so it should be no surprise that the street has largely moved inside the mall corridors, complete with movie marquees, light posts, sidewalk cafes, decorative fountains, rows of street trees, benches, and a variety of traditional building facades, materials, and signage. Usually, the outside walls of the mall are massive and blank, great gray or white monoliths looming over a vast and increasingly unsafe sea of parking. Similarly, many large office buildings now have

tree and cafe-filled atria with much of the symbolism of a small-town courthouse square. "Streets" may consist of tunnel-like second- or third-level walkways connecting one building to the next. The world has gone inside, and we might as well follow.

To a lesser, but still significant, extent, the same reversal has occurred in many residential complexes. Gated communities, some raised on platforms with parking underneath, normally have their own versions of house facades, steps, entryways, porches, and patios all within a private space. The symbolic design relationships between private and public space often remain, but the public space is nonexistent because the sidewalks and streets are all within a private compound. Private features interface with private features in a nostalgic but largely meaningless way. Only those with a key can use them. In appearance at least, the more things change, the more they remain the same.

As lamposts and trees have moved inside, private spaces once only associated with the insides of buildings have moved outside. The most obvious examples are the pedestrian "malls" that transformed many Main Streets during the 1960s, but there are less obvious examples as well. Many settings that appear from a distance to be complete towns, such as Disney's Celebration, near Orlando, are actually private developments, owned by one corporation and designed and monitored to the last detail just like enclosed malls. While there may be streets, sidewalks, and stop signs, things are not as they appear. What seems to be a busy metropolis is really a private front yard. The juxtaposition of symbols can be confusing.

So I discovered while standing on what appeared to be a sidewalk next to a busy, skyscraper-lined thoroughfare in one of Atlanta's edge cities. When I raised my camera and began taking a few city photographs, out of nowhere, a uniformed security guard approached and gruffly informed me that I needed

permission and an official badge to take photographs anywhere in the "neighborhood." The entire end of town was private property. The spaces between buildings had ceased to exist, at least for the public.

|| Enclosers of Space

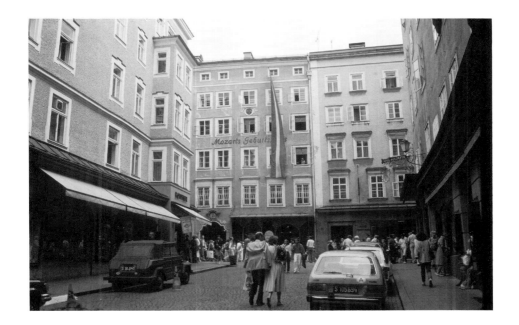

Salzburg, Austria: An urban space enclosed by buildings is typical of
European cities with architecture dating from the Renaissance.
Here, architecture is used to decorate space.

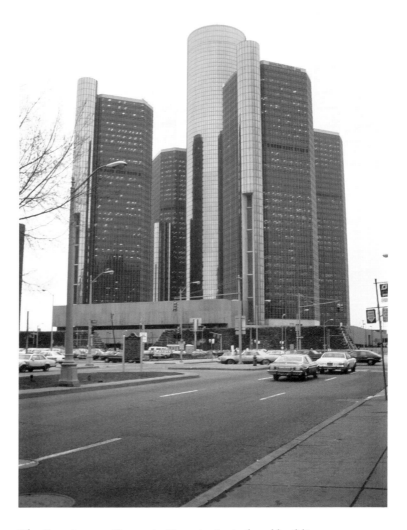

The Renaissance Center in Detroit: An isolated building surrounded by space is typical of much of modern urban America. Perhaps urban renewal schemes aimed at ameliorating congestion and density worked too well.

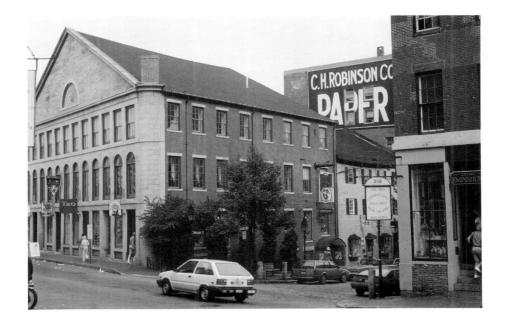

A decorated facade in Portland, Maine, adds character to the urban fabric, but since adjoining buildings have been pealed away modest sidewalls heighten the artificial nature of the lavish facade.

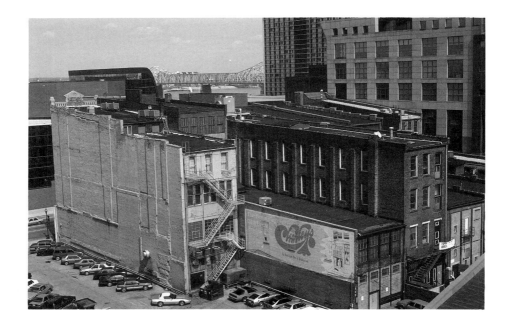

These unadorned sides and backs of buildings in Louisville, Kentucky, were never meant to be seen. The uneven demolition of row buildings has led to much of the ugliness associated with older urban areas in America.

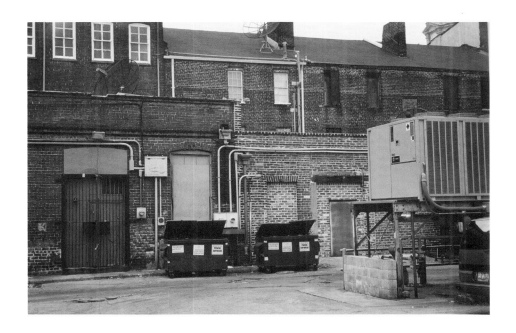

Plumbing, air conditioners, and dumpsters dominate the backs of buildings in Charleston, South Carolina. Much of the machinery of living has been tacked on to the alleysides of American buildings.

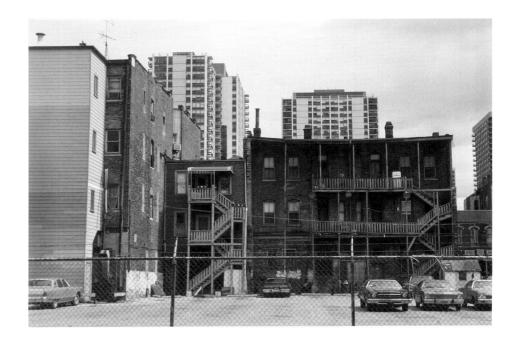

Back porches, stairways, and a parking lot define the backs of these buildings in Chicago. Porches that were once functional for hanging out laundry and socializing now share space with open fields of parking. The never-intended relationship can be jarring.

Machinery clutters the rooftops of Atlanta, Georgia, and adds a
new visual element to architecture. As buildings are built to varying
heights, cluttered rooftops become visible from several angles.

A minimalist gas station and the blank walls of a telephone building make for a dreary scene in San Diego. Street scenes once dominated by front doors and facades are now often characterized by entryless, minimally decorated surfaces.

Side porches and a driveway fill the spaces between buildings in
Charleston, South Carolina. As row houses gave way to free-
standing structures, new features evolved to fill the spaces between
buildings.

A string of front porches in Columbus, Ohio, provides an ideal setting for social interaction, but television and air conditioning have taken a toll on such casual socializing, and the desire for privacy now often exceeds the desire to chat with neighbors.

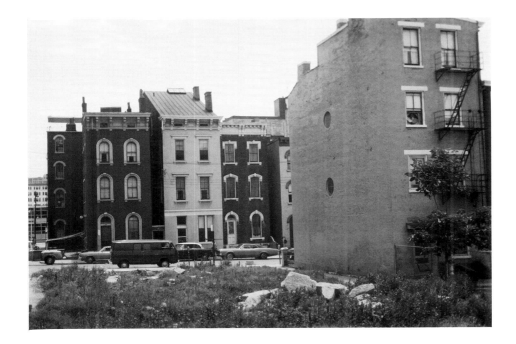

The partial destruction of a row house neighborhood in Cincinnati, Ohio, has led to empty space and exposed blank walls. Long, exposed sidewalls represent a major challenge to muralists and neighborhood planners seeking to soften the impact of demolition.

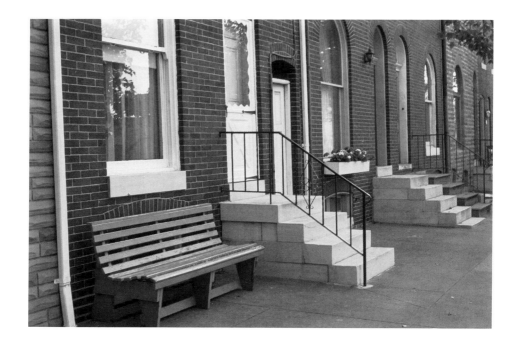

Marble stoops and benches soften the facades of Baltimore row houses. Even very small spaces can be personalized and decorated with useful and symbolic features.

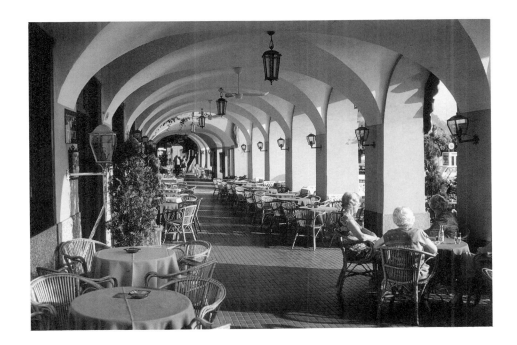

An arcaded street provides a sense of beauty in Bellagio, Italy.
Good buildings are often those surrounded by semipublic space
that diminishes the transition between inside and outside.

Top: In Orange County, California, an artificial door decorates the outer wall of a shopping mall. As urban life has become internalized in malls, office buildings, and hotel atria, the walls facing outward have become either blank or misleadingly decorated. *Bottom:* An entry gate and decorative hedge provide a manicured sense of enclosure in San Diego. A sense of territory and defensible space can be achieved with symbolic elements such as grand entryways.

An architectural mural of a "windowscape" dresses up a blank wall in Milwaukee, Wisconsin, in art deco style. The blank sides of tall buildings, which were once used for garish advertisements, are now sometimes part of urban beautification schemes.

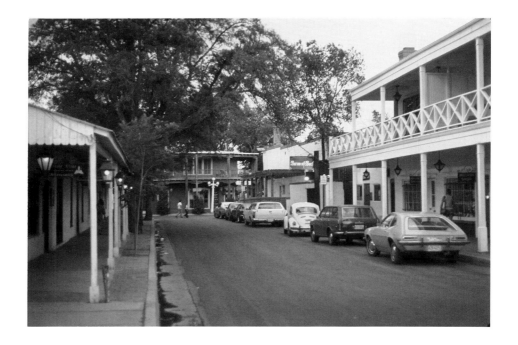

Multiple enclosures create a special ambience in Old Town Albuquerque, New Mexico, from walking under the portals of Territorial style architecture to strolling the old city streets to enjoying the intimate views from second story cafes, galleries, residence, and shops.

TWO ‖ Lawns, Trees, and Gardens in the City

84

As early as 30 b.c., Horace wrote: "This used to be among my prayers—a piece of land not so very large, which would contain a garden, and near the house a spring of ever-flowing water, and beyond these a bit of wood." Yet for thousands of years, most of the towns and cities of the world got by with little or no vegetation within the city walls. When streets were narrow and winding and the built environment was dense, vegetation was likely viewed as a "weed" that impeded movement or invaded productive space. The idea of planting trees in narrow, congested lanes already full to overflowing seemed like nonsense to the typical urban dweller, still accustomed to viewing the forest as a threatening place inhabited by trolls or worse. Many medieval cities specifically barred trees from their centers. Even grand, open public spaces or plazas were unlikely to have much vegetation. Central plazas, the gathering places for political and religious events, were, if at all possible, paved. Even in the newer cities of America, vegetation was not common in public spaces. Old photos of Spanish plazas in Texas and California, for example, show them to be dusty open spaces without a tree or bush in sight. Today, one of

THE SPACES BETWEEN BUILDINGS

the issues in historic preservation planning in such plazas re-volves around whether or not all vegetation should be removed in order to achieve historic authenticity.

In late-twentieth-century North America, greenery has largely won the day, although there is a growing minority seek-ing alternative design strategies. Most Americans feel that if a space is not being used for parking then it should be green. Downtown urban renewal projects often result in the insertion of dense urban forests into even the smallest spaces between buildings. New atria in office buildings and hotels sometimes make possible a plentiful supply of trees and flowers inside as well as outside. As a culture, we like our vegetation and our cities are full of it. As the fabric of the built environment has loosened, we have created a variety of vegetative assemblages to fill nearly every possible type of space. One of the earliest and certainly most pervasive types of vegetation associated with the North American city and suburb is the grass lawn.

The Origin of the Lawn Aesthetic

Lawns are as American as apple pie. When one thinks of res-idential neighborhoods, parks, campuses, modern office devel-opments, or any other type of open space, the dominant image is of sweeping green lawns. Even in the hearts of our largest cities, vast expanses of green lawns are common and expected. America's cultural preference for comparatively large amounts of open space may be related to our need for lawns. We may, however, have created a monster. We now have so much space between our buildings that almost nothing, aside from lawns or parking, can fill it. In this essay, I explore the origin, diffusion, acceptance, and impact of our widespread infatuation with the lawn.

It is no small effort to maintain the lawns in America. They

require much attention and use up an enormous amount of resources. Lawns cover nearly 30 million acres in America, an area about the size of Michigan or New England. In the summer, they absorb up to 60 percent of many metropolitan water supplies according to one authority. The million tons of fertilizer spread on lawns alone in the United States is roughly equivalent to the amount that India requires to grow all of its food; moreover, the 70 million pounds of chemicals spread over lawns each year produces significant environmental degradation. Yet lawns are big business too. More than 500,000 people work in what has become a six billion dollar per year industry.

Are we addicted to grass? Scholars such as Virginia Scott Jenkins have referred to the lawn as "an American obsession." Roughly two-thirds of all American households have some variety of lawn, and many modern offices, hotels, convention halls, and shopping complexes follow suit. Our national mythology sometimes seems to assume that lawns were part of our natural heritage and that the English colonists simply added cottages and churches. In truth, however, the lawn is a very artificial thing, invented in Europe, and only gradually introduced to North America. Indeed, lawns rarely appeared in America until the middle years of the nineteenth century. For a long time, it was not at all obvious that they would catch on.

The decorative, manicured lawn likely originated in France and Britain during the seventeenth century in order to provide appropriate vistas for grand estates and country manors. Lawns became particularly popular in England, where designers such as Lancelot "Capability" Brown helped to create the look of studied rusticity, an important component of the English landscape aesthetic. The large estates of England had long featured fields of native grasses, since raising sheep was an important economic activity, but the rolled and trimmed lawns that came

into vogue in the seventeenth century were quite another matter. As it became fashionable to have uninterrupted views both of and from the manor house, the lawn, with an occasional picturesque clump of trees, became the English landscape ideal, one emulated by all who could afford it. However, not many could. At first, only those with enough time and money for a jolly fox hunt or a game of tennis really needed a lawn.

Both cultural and environmental factors made it difficult to diffuse the idea of a grass lawn beyond the confines of northwestern Europe. Many cultures, including those in such long-settled places as India and China, did not crave grass, and some even had an active aversion to it. Grassy expanses, considered unattractive, were thought ideal hideouts for snakes, rodents, insects, and maybe hungry tigers. People preferred to have packed earth or paving stones wherever possible. In most of the world's *urban* settings, lawns were unthinkable. Useable space was at a premium and water supply systems, where they existed at all, were barely capable of providing for human consumption. Besides, having large expanses of grass in the center of town was of marginal importance to those only one step away from peasantry. Why bring the country to the city when there is so much of it just beyond the gate?

This attitude changed throughout the world gradually, over the course of several centuries, with the diffusion of English tastes through colonization. Over time, cricket fields and green parks appeared from Kuala Lumpur to Durban. While the new lawn aesthetic was initially imposed in most colonial settings, evidence suggests that citizens in many locales came to accept it wholeheartedly. However, as new symbols of national identity evolve and as resource scarcities become more threatening, some changes in the worldwide distribution of lawns have occurred. Even in North America, many people have second

thoughts about emulating the English lawn ideal. But let us first examine how the lawn became ubiquitous.

The Lawn Arrives and Thrives in North America

The first recorded use of the term *lawn* (probably Welsh in origin) in North America occurred in 1733, well before the lawn aesthetic would grow popular on this side of the Atlantic. Where they existed at all, front yards, usually fenced, were used for vegetable gardens or animal pens. Even town commons normally featured bare earth, hay for fodder, or—where grass grew—grazing cattle. While there were many rough-and-ready native varieties, none of the grasses commonly used in European lawns were native to North America; hence fragile, velvety expanses were hardly appropriate for the pragmatic, workaday life on a new frontier. Lawns were for *flâneurs* and fops, not red-blooded Americans.

The lawn appeared in America with the gradual adoption of English landscape tastes during the first few decades of the nineteenth century. The work of popular English landscape painters like John Constable featured expansive lawns and country scenes. Books and "how-to" manuals also helped to diffuse the new aesthetic. But the rate of adoption of the lawn aesthetic in America was uneven, Virginia, with its burgeoning tradition of large estates and emulation of the English aristocracy, leading the way. The widespread popularity of the lawn did not arrive until long after independence. Perhaps in the national psyche, colonial status was still too recent for enthusiastic emulation of the mother country. Similarly, the land ownership patterns and abundant labor that made great estates possible in England did not exist in most parts of the United States. Then there is the difference in physical environment. The hot, seasonal droughts that were common in much of the

South deterred English grasses, even where slave labor allowed for meticulous maintenance. The infatuation with Greek Revival architecture and Classical imagery during the first decades of the nineteenth century also delayed full acceptance of England as an aesthetic role model. For these and a variety of other reasons, enclosed, swept dirt yards and vegetable gardens prevailed in most areas until midcentury.

Then, as the 1840s and 1850s brought a variety of changes in attitude and technology, proper English landscapes began to appear. This period also saw the first tentative efforts of planned suburbanization. Books by influential writers such as Andrew Jackson Downing helped to refine aesthetic tastes. His *Theory and Practice of Landscape Gardening* (1841) coincided with a number of town improvement movements that led to an increased awareness of, and dissatisfaction with, the ragged and disheveled appearance of many American places. New planned suburbs like Riverside, Illinois, requiring widely-spaced houses and unfenced, generous yards, had appeared by the 1860s. In addition, the gradual completion, during the middle decades of the nineteenth century, of new national symbols such as the Capitol, the White House, and the Washington Monument, all gracing the muddy and ill-defined mall, spurred the acceptance of the lawn aesthetic. The public park movement of the 1850s and the expansion of omnibus lines to relatively low-density communities encouraged experimentation with finer, more aesthetic European grasses as well as new hybrids.

New technologies also began to make an impact around midcentury. The first lawn mower, for example, was invented in England in 1830, but it was not mass-produced as there was little demand for it. Gradual improvements occurred in both England and America during the 1850s, and by the 1860s lawn mowers became reasonably practical and affordable. The first

patent for an American mower was awarded in 1869. Although fewer than 50,000 mowers existed in the United States in 1880, they helped the coming aesthetic change, as it was no longer necessary to have a horde of men with scythes to maintain a clipped lawn. Advances also came about with hybrid grasses, fertilizers, rollers, municipal water systems, hoses, sprinklers, and a variety of technologies associated with promoting the popularity of grass. By the 1890s, electric streetcars allowed commuters to travel to ever more distant greener suburbs. Chicago, a relatively new city, became known as "the Garden City" because of its numerous front lawns.

The increasing importance of leisure time and sports also helped to sell the lawn idea to the newly emerging American middle class, intrigued by lawn tennis and several new activities like golf, croquet, badminton, archery, football, and especially baseball, which gained popularity during the nineteenth century. All of them depended, to one degree or another, on the availability of grass playing fields. The better the grass, the better the game. This was especially true of golf, and the number of country clubs in the United States exploded between 1880 and 1900. The "golf course look," with a monoculture of low, sleek, fine grass, became the standard criterion for all lawn owners. The emerging sports establishment spent millions of dollars developing hybrids, fertilizers, chemical treatments, water technologies, and anything else that would make better and more perfect golf courses and, in time, baseball fields. The golf industry alone spent about 10 million dollars a year at the turn of the century to develop newer and better greens.

Less directly, the popularity of bicycles and automobiles led to new parks and greenways to be enjoyed by picnickers and enthusiasts of these new forms of mobility. By 1912, the open, unfenced green front lawn was pervasive, at least in the North-

east and Midwest. The South and West resisted somewhat, since the climates there are not hospitable to English-style lawns, even with the new hardier hybrids. In fact, some golf courses in Texas and California used oiled sand well into the twentieth century.

During the last decades of the nineteenth century, the federal government, as well as some state governments, increased their levels of involvement in the turfing of America. The government had been involved in the distribution of seeds and the introduction of new types of grass to the American continent since the late eighteenth century, but initially its activities had revolved around function more than aesthetics. Bermuda grass, for instance, had been introduced during the nineteenth century as a way to stabilize canal and railroad embankments, although it worked well on the newly emerging sports fields too. But, spurred on by the City Beautiful Movement at the turn of the twentieth century and a new round of enthusiasm for improving the urban (and suburban) landscape, the government undertook research on more decorative varieties of hybrid lawn grasses in its agricultural experiment stations. Many people advocated these efforts, among them the developers of suburban housing estates and the builders of golf courses, city parks, baseball stadiums, college campuses, and garden apartments, all of whom were eager to see an improvement in the available variety of grasses. In the end, as the urban framework loosened, there would be a concerted effort to fill the intervening spaces with grass.

The Parklike Lawn and the Suburban Ideal

By the early decades of the twentieth century, the manicured lawn was second only to the single family house as an emblem of the suburban ideal. The cozy cottage set in the mid-

dle of a green lawn was as good as it could get. The lawn was time-consuming, expensive, and nonfunctional, but for most people it was an aesthetic and symbolic necessity. Indeed, Thorsten Veblen argued in *The Theory of the Leisure Class* that Americans desired lawns precisely because they were nonfunctional. As a pure status symbol, the lawn demonstrated that the owner had the time and money to enjoy nonproductive pursuits. The lawn also complemented and supported the residential architectural styles that were becoming popular at the time. The Craftsman Cottage, English Tudor, Dutch farmhouse, and even Spanish Colonial styles all looked good sitting in the middle of a lawn. Studied rusticity was admired. As the twentieth century progressed, Green lawns became not only more common but also more open.

Ironically, the English landscape tastes that had inspired the open suburban lawn in America rarely had the same impact in England itself. Front yards in English suburbs tend to be walled and gated, and they are as likely to be filled with rose bushes as with grass. It is also common to have a slightly scruffy assemblage of mismatched trees and hedges in the English urban landscape. Not so in America, where the clean lines of a smooth, neatly trimmed, unfenced front lawn set the standard. By the 1920s, many American communities mandated an open front lawn and disallowed any type of fencing. The gradual acceptance of zoning codes and other types of regulations also facilitated the imposition of required uniform setbacks. As houses retreated from the street, open grass lawns typically usurped the available space.

Although about 80 percent of all American lawns are privately owned, this does not mean that they cannot contribute to neighborhood aesthetics. Front yards are visually enjoyed by the entire community, and they are not thought of as just pri-

vate property. Neighborhood greenery can be seen by all but used only by invitation. It is as if the lack of parks and other public open spaces is ameliorated by coopting a bit of everyone's front yard. Some people object to this arrangement, and critics have lamented that property rights are infringed upon by authorities who mandate open, visually communal lawns. The counterargument contends that open lawns enhance property values, a view that carried the day in most communities, at least until the 1980s. Indeed, the lawn image sells. There are more than 150 communities in the United States with *lawn* as part of their name, such as Lawndale, California, or Fairlawn, Ohio.

The diffusion and acceptance of the lawn, however, has not always been smooth, even in the twentieth century. The adoption of lawns slowed during the Great Depression and World War II and then accelerated during the suburban boom of the 1950s. Physical barriers have also impeded acceptance. Maintaining a smooth and manicured lawn still posed an uphill battle in much of the South and West in the early 1950s. However, this midcentury hiatus was only the calm before the storm. By 1960, a variety of new technologies, hybrid grasses, and water distribution systems made lawns possible throughout the country.

With the postwar suburban explosion, lawns became nearly ubiquitous and the battle against crabgrass and other obstacles that stood in the way of achieving the golf course look began in earnest. Terminology left over from the war was eagerly adopted by enthusiastic lawn warriors during the 1950s: The chemical weapons of choice often had names such as "Weed-a-Bomb" or "Killer Kare," and one brand described itself cheerfully as "the atomic bomb" of insect control. Even the politics of the McCarthy era were reinforced by lawn care, at least indirectly, when William Levitt (developer of Levittown) proclaimed that homeowners did not have *time* to be communists.

LAWNS, TREES, AND GARDENS IN THE CITY

An old adage from 1923 also seemed appropriate for the times: "The price of a good lawn is eternal vigilance." Oddly enough, the Pentagon was constructed on a site that had been previously used for developing hybrid lawn grasses.

New hybrids and technologies made the concept of the ideal lawn nearly universal by the 1960s. A tremendous variety of new grass hybrids had been developed, and one type or another could be used singly or in combination in almost any environment. Bent and blue grasses, ryes, white clovers, and redtops are but a few. In addition, new dams and water delivery systems, such as the Glen Canyon Dam in Arizona and the California Aqueduct, made irrigation possible in nearly every urban area from the mountains to the deserts. Now lawns really were feasible everywhere and, in the rare situations where they absolutely could not survive, there was always Astroturf.

Along with suburban yards, America's city parks, college campuses, golf courses, highway median strips, sports fields, military parade grounds, race tracks, and office and industrial parks all boomed in the postwar years, filling up with generous expanses of grass. Even as land and labor costs soared, the landscape aesthetic of individual buildings set in a carpet of green became ever more popular, and there was a corresponding boom in the various kinds of accessories that good lawn care requires. In addition to the hoses, sprinklers, trimmers, rakes, rollers, wheelbarrows, and fertilizer and chemical spreaders necessary to make lawns grow, Americans bought nearly 7 million power mowers in 1990 in order to keep their lawns' growth under control. Why has the expensive and time-consuming lawn aesthetic become so important? Why do we construct high-rise office buildings to aid face-to-face communication and then separate them with vast lawns—"the skyscraper in a park" aesthetic—maintained by an expensive staff of gardeners using

a fleet of noisy and polluting machines? Are the sprawling residential and commercial designs we encourage through our zoning and building regulations a function of our deeply ingrained preference for green lawns, or do we simply like to have a lot of space around us? Some underlying values may explain our "buildings in a field" urban design policies.

Underlying Values and Perspectives

Some would argue that a love of green lawns is a basic human characteristic. This argument has its origins in ethology and is related to our species' alleged search for settings that allow for both prospect and refuge, such as savanna grasslands with clumps of trees. While most advocates of this view avoid extreme ethological positions, they often maintain that grass lawns are somehow more soothing and refreshing than any conceivable alternative and that high levels of serenity can be achieved by, say, rolling in the grass. The fact that many cultures do not value the lawn aesthetic complicates this argument, but it could be that the desire to avoid man-eating tigers and poisonous snakes can simply override aesthetic values. We may value beauty only when the snakes are gone. In the relatively tame environs of suburban North America, however, grass is soothing.

A second underlying reason for our love of grass is that manicured lawns may represent our ability to control and shape nature and demonstrate our superiority over it. Geographer Yi-Fu Tuan, for example, suggests that we have been attempting to shape and control nature for a very long time and that our struggles have resulted in a number of different landscape features, from oriental gardens to massive reservoirs. The lawn represents only one possible outcome in this scenario, but it does explain why we seem to worry excessively about a lawn

being "out of control" or "wild." A neat and carefully trimmed and rolled lawn represents victory over the forces of nature. Serenity only arrives after we have shaped our utopias. Paradise, after all, is nearly always depicted as a garden, not a wilderness.

A third argument for lawns has to do with cultural heritage and the emulation of an idealized elite. This brings us back to the adoption of English landscape tastes and the image of a picturesque and romantic version of the countryside. Not only do our lawns, as well as many of our period revival house types, reinforce this image, but so, too, does our use of language. Even our biggest cities are full of places called villages, cottages, country inns, lanes, and meadows. Indeed, it sometimes seems as though every shopping center with less than one million square feet of space is required by law to be called a "village." Larger ones are called "town centers."

A fourth argument suggests that our love of lawns is related to the influence of special-interest groups. At first, perhaps, artists and reformers interested in improving the landscapes of America may have pushed an image of the ideal lawn with little thought of benefiting themselves. Later, however, some groups and industries did thrive because of the acceptance of the lawn aesthetic. To the extent that government research projects provided hybrid seeds with the aim of achieving better country club fairways in every part of the nation, it could be suggested that a particular taste was being heavily subsidized at the expense of others. If those benefiting from the government's largesse could argue that *all* homeowners wanted to achieve "the golf course look," the subsidy might be justified. Advertisements suggesting that soft, velvety lawns were a must often resulted in such desires. By the 1950s, the lawn care industry was booming and television and magazine ads for lawn

mowers, trimmers, rollers, and a variety of other products suggested that a well-tended lawn made for immense quantities of good family fun. With a big enough lawn, you could even get a riding mower and cruise. Soon, residential lawns were touted by distributors of sports and recreation equipment as well. Obviously, the croquet lobby alone did not make the lawn an American obsession, but it, like a lot of other businesses, did have a stake in America's love of green grass.

The rise of a Victorian-derived cult of domesticity and its subsequent "Leave it to Beaver" variations in the 1950s and 1960s also played an important role in lawn promotion. The idea that each nuclear family should have a private home as far away as possible from the evils of the commercial and industrial city was new in the late nineteenth century. Children had grown up in the middle of cities for thousands of years, but many Victorian reformers argued that this was no longer acceptable. The Victorian house, with separate rooms for children and adults, likely inspired the organization of the increasingly desired private yard, complete with carefully designed play areas. Proper families should frolic at home, not in the streets or in commercial areas. Indeed, derogatory terms such as *street urchin* and *woman of the street* came into parlance. Each segment of society was to have its proper place, and the lawn was ideal for the middle-class family. Swings and teeter-totters were optional.

Finally, the continued popularity of the lawn is certainly partly related to government codes and regulations that have served to institutionalize particular kinds of landscape tastes. Municipalities have played a major role in the diffusion and acceptance of the lawn by requiring large setbacks, disallowing fences, and even mandating the types of grasses that can be grown and how high or brown they can become before a resi-

dent is fined. Sometimes, cities will mow offending front lawns and then bill the owners. The governing boards associated with many planned unit developments have even more power. Some have the equivalent of "three-dandelions-and-you're-out" foreclosure procedures. Many of these regulations have been questioned in recent years, and changes are afoot. Still, a great many people think that it would go against societal conventions not to have lawns.

Lawns in the Age of Environmental Awareness

Ironically, enthusiasm for green lawns probably peaked during the 1960s, at about the time that books such as Rachel Carson's *Silent Spring* began to pique concern about environmental degradation. With the celebration of the first Earth Day in 1970 and the realization that many of our resources are not limitless, Americans in general were more willing to imagine a greater range of alternatives for the vast spaces we had created between our buildings. Advocates of lawns maintain that grass is environmentally friendly. Lawns, they insist, produce oxygen and cool cities and, perhaps, tempers, by reducing reflective heat on hot summer days. There can be little doubt, however, that lawns contribute to environmental pollution in a number of ways. Chief among these are the noise and air pollution from mowers and weed-eaters and the ground and water pollution associated with the use of fertilizers and chemicals.

The perceived aesthetic need to keep lawns well mowed and trimmed is a major part of the problem. California's Air Resources Board has determined that the small, two-cycle engines used in power lawn mowers emit as many pollutants per hour as driving an average car 350 miles. The impact of this is significant: about 5 percent of the hydrocarbons in California's air come from gasoline-powered mowers and trimmers. Noise lev-

els can be deafening on the first warm evening in early summer. Obviously, some of these problems can be ameliorated by developing quieter, less-polluting machines, but the fact would still remain that mowers and trimmers are not really essential, except to the degree that closely cropped lawns are seen as necessary. There is also the related problem of lawn waste. Lawn clippings account for nearly a fifth of the volume of typical land fills. Many cities will no longer pick up lawn waste with normal garbage collection, forcing individuals to haul grass down to the dump.

According to Virginia Scott Jenkins, in *The Lawn: A History of an American Obsession*, the million tons of fertilizer and 70 million pounds of chemicals put on lawns each year cause serious problems. There are concerns about the relationship between lawn fertilizers and birth defects, as well as some worries about the impact of treated grass on pets and wildlife. Suspicions were aroused in New York when 700 geese landed on a newly treated golf course and subsequently died. Runoff from large parks and golf courses, especially when combined with runoff from agricultural areas, has also affected many streams and rivers, putting fishing and other recreational activities at risk. Indeed, suburban runoff has now surpassed industrial pollution as a threat to the continued health of the Great Lakes. Some chemicals have been banned in the United States (DDT since 1972), but the search goes on for acceptable combinations of chemicals. Concerns have also arisen about the tens of thousands of people who have been injured by lawn mowers over the past five decades. A variety of safety regulations have been enacted, but danger remains.

Yet of all the controversies surrounding the green lawn, none has sparked more debate than water usage. This is especially true in the arid Southwest, but even in other parts of the

country, seasonal droughts can make watering one's lawn unadvisable or even illegal. As populations have exploded in sunbelt cities and as lawns have become common in everything from office parks and golf courses to bike paths in planned unit developments, water consumption has become a crucial issue. Many desert communities now require, or at least encourage, the use of drought-resistant (xerophytic) vegetation. Environmentalists have argued that trying to grow grass in the desert is about as silly as trying to grow kelp. Even in the moisture-laden northeastern and northwestern quadrants of the country, it has become fashionable in more than a few places to have "natural," unmowed grasses or a mixture of "wildflowers."

One of the first cities to seriously question the dominance of the lawn aesthetic was Tucson, Arizona. Beginning in the 1880s, Tucson was transformed from a dusty, desert town where cacti reigned supreme to a grassy replica of the Midwest. Not everyone was happy about this. To many of the people who had moved to Arizona to escape pollen-related allergies, the lawns and gardens that were moving to the desert along with the people were troublesome. Early on, some neighborhoods banned Bermuda grass and other types of vegetation thought to be responsible for common allergic reactions. Nevertheless, during the boom decades of the mid-twentieth century, water-intensive lawns and trees were planted throughout the city. This transformation required large amounts of water, a resource in short supply in Tucson.

For most of its history, until the Central Arizona Project was completed in 1992, the city had relied exclusively on groundwater to supply its needs. Several droughts during the 1970s and early 1980s severely stressed water supplies, and a substantial rate increase for water consumers was subsequently put into effect. For some residents, alternative vegetation became an

economic necessity, reinforced by water prices that go up with usage. Many lawns and public greens have been replaced by drought-resistant plants, rock, paving stone, or decorative gravel arrangements. Gradually, the original desert look has become a valued landscape as the natural environment of the region has been romanticized, domesticated, and combined with Southwestern architecture in order to purposefully enhance the city's sense of place and uniqueness.

New Trends in California Yard Design

Like Tucson, many of the cities of California reflect the growing importance of alternative landscape tastes. San Diego is a case in point, where, for a variety of reasons, full, unbounded grassy lawns are far from the norm. During the spring of 1995, I surveyed more than one thousand front lawns in six very different types of San Diego neighborhoods and cataloged them with regard to dominant vegetative cover or other land use. While 48 percent of the yards included some grass, only 22 percent of the total consisted of full, uniform lawns, while 26 percent had plots of grass mixed with shrubs, rock gardens, or other design features; yards that featured only alternative types of vegetation, such as trees and shrubs, succulents, flower gardens, or ivy, made up another 32 percent of the sample; yards that featured little or no vegetation made up 18 percent. Paving, brick or stone patios, wooden decks, rock gardens, gravel, bark chips, and swept dirt were the most common of these options. Some yards were enclosed by high fences of stone or wood, and views through fences only rarely confirmed grass on the other side. Enclosed space most likely included a patio, and walled yards that could not be confirmed were included in the nonvegetation group. Another 2 percent of the front yards fell into the indescribable category, which included one dubbed

"vegetation chaos." In San Diego, unlike some older row house cities, every lot has some front setback from the property line, and so there was always a space to examine and classify. With high costs for land and housing, however, these front spaces have gotten much smaller in recent years.

Yard type varies significantly from neighborhood to neighborhood in San Diego, with the percentage of those having full grass lawns ranging from a low of 2 percent in one neighborhood to a high of 50 percent in another. Three of the six communities examined had percentages in the 20-30 percent range, which was similar to the overall total. Governmental regulations occasionally play some role. One municipality in the San Diego area allows much higher fences on or near the front property line than any of the others. In every area, however, the number of full grass lawns was rapidly decreasing. In some cases, rechecking a neighborhood after a period of three weeks showed several new yard design alternatives had appeared in place of grass. Often there is a contagion effect. No one wants to be the first to break the open neighborhood lawn vista, but once it is done, nearby residents quickly join in the search for creative alternatives. Full grass lawns do not constitute a majority of front yard designs in any neighborhood, though. While backyards were not surveyed, air photos and other data suggest that pools and patios predominate and grass lawns are much less common there than in front.

Several reasons can be identified for the decreasing popularity of lawns in cities like San Diego. Some are common to a number of places but, in combination, they probably make San Diego less enthusiastic about lawns than the average American city. These are: a benign climate, making possible a wide variety of vegetation options; the high cost and often limited availability of water; difficult topography; small, expensive lots with

shallow setbacks; the popularity of Spanish and Southwestern architecture; the perceived need for front parking spaces; and the recent arrival of many non-Anglo immigrants who are less enamored of English landscape tastes.

The first three reasons have to do with physical geography and the city's location in a warm, hilly, semiarid region. San Diego gets about 3,200 hours of sunshine per year, or about 73 percent of the maximum possible. Temperatures average in the 50s during the winter and 70s during the summer, and extremes are rare. The urban area gets only about 9-15 inches of rainfall (depending on location) each year, and 90 percent of the city's water must be imported over great distances. In addition, most of the San Diego urban area is located either on a dissected plateau or in the foothills of the Laguna Mountains. There are relatively few flat neighborhoods, and mowing a lawn can be a roller coaster ride. All of this makes lawns problematic. A wide variety of succulents, flowers, cacti, bushes, and charming little exotic trees can thrive in the city, making landscape architects enthusiastic about creative alternatives to a grass lawn, especially alternatives that consume less water.

Lawn conversions, just like lawn maintenance, can create jobs. Local magazines and newspapers frequently run stories featuring pictures of the wonderful and environmentally friendly designs that are possible. People wanting to upgrade their homes often do so by incorporating exotic and individualistic yard statements. Examples include desert scenes with giant boulders and towering cacti, "natural" prairies with tall clumps of hardy grasses, and patios with potted plants and raised flower beds. Some parents have defended their designs by suggesting that monoculture grass lawns tend to dull children's minds by isolating them from the wonders of biodiversity.

In many San Diego neighborhoods, steep banks and pro-

truding rocks make lawns almost impossible to maintain. In addition, many houses are built on canyons, and back yards sometimes drop off precipitously. In such cases, there are two options for creating outside living space—building a wooden deck over the canyon or creating a front patio. The latter is cheaper and usually more protected from wind and sun, so fenced front patios are gaining in popularity, especially as lots become smaller and more expensive. Open, sweeping front lawns are being recaptured for useable living space; they are no longer considered to be community open space.

The popularity of Spanish and Southwestern architecture in San Diego also makes it easier to develop alternatives to the lawn. Walls, patios, archways, and additional rooms can be added to the front of Spanish style structures with relative ease. Many eastern house styles, on the other hand, feature a formal front facade that can accept little modification or extension. Walls and patios look misplaced in front of a Georgian Colonial house. The blurred distinction between inside and outside in Southwestern architecture not only makes additions easier to pull off but also encourages experimentation with xeriscapes and even plain dirt or gravel, in which dusty adobes look at home, especially with bougainvillea.

San Diego, like much of California, has attracted large numbers of immigrants from Asia and Latin America, many of whom do not share European landscape tastes. Walls, gates, gardens, gravel, raked dirt, and front yard workspaces tend to be more common in ethnic neighborhoods. The idea of using valuable space for open lawns is not always easily accepted in such communities, where residents feel it is better to grow vegetables or place statues of the Virgin Mary or Buddha.

Many houses have paved parking areas over all or part of what normally would be the front lawn. Garages often have

been converted to living or work space, while the number of automobiles per household has escalated. Cars sometimes dominate the domestic scene, a feature that will be discussed in the third section of this book.

Deciding to Change the Front Yard

In terms of long-term sustainability, America may have planted itself into a corner. For over a century, proponents of lawns have played a major role in creating ever larger amounts of both private and public open space. Beginning in the middle of the nineteenth century, with Frederick Law Olmsted's plans for Central Park in New York City and the development of early suburbs, the desire for and promotion of vast grass lawns has served to open up the urban layout and push the buildings of the city further apart. As the house in the middle of a one-acre lot became the suburban ideal, office and industrial buildings later emulated this model. But what if tastes drift away from the grass lawn because people start to view it as expensive and environmentally suspect? What can be used to fill all of the space we have created? Americans have never embraced the paved plazas of Italy, the swept dirt promenades of Paris, or the raked gravel designs of Japan. Often far too much space surrounds American buildings for labor-intensive flower gardens to be a viable option. Hence, some basic spatial questions arise concerning how buildings in cities should be sited. Do lots need to be as large if the lawn aesthetic diminishes?

A growing number of people in southern and northern California either have changed or would like to change the design of their yards and move toward landscapes that are both low maintenance and drought resistant. A few cities, such as Novato, offer cash incentives to homeowners who reduce the amount of grass in their yards. The emergence of Asian and

other non-Anglo businesses specializing in alternate lawns and gardens, as well as books and articles on easy-care designs, have facilitated the switch. People are gradually gaining the confidence to go against the grass lawn tradition. "Hell, everyone on this block except me and my neighbor has a damn lawn. We got wise," remarked one resident surveyed by Christopher Gramp in Albany, California. There is, however, often a perceived social pressure not to experiment with alternative types of vegetation. The main deterrent to eliminating the front lawn is usually the fear that neighbors will object and the new design will be vilified. In such cases, the contagion effect becomes very important in reducing social pressure. Homeowners are reluctant to be the first on the block to make a change, but once the movement begins it often snowballs.

While ideas for lawn alternatives can come from many sources, including Southwestern-theme magazines like *Sunset*, government publications, gardening books, landscape architects, and friends, the new designs that appear in a specific neighborhood may have the most impact on homeowners nearby. These alternatives, if they take hold in the local soil and climate, serve to break up community norms. Consequently, even within the same part of town, different blocks and different neighborhoods may exhibit different types of front yard design. Front yard landscape types are increasingly joining house types in defining a community's sense of place.

While California and the Southwest have led the way in the search for lawn alternatives, other parts of the country are getting actively involved in the quest, spurred by occasional seasonal water shortages, pollution, and overloaded landfills. In Columbus, Ohio, the city banned watering lawns during an extended drought in the early 1990s and also established a policy of not allowing pickup of lawn waste as a part of normal trash

removal services. The latter restriction forced citizens to either develop compost piles, rent trucks to get their clippings to the dump, or design new types of yards. Many people built decks and patios in their backyards, but front yards posed a greater challenge. Gradually, rocks, mulch, trees, shrubs, and flower beds took over at least part of many front domains. As might be expected, alternative vegetation caught on quickest in small front yards. A windshield survey of about 500 Ohio front yards in 1994 indicated that about 82 percent had full or partial grass lawns; a much higher percentage than in Arizona or California. Still, experimentation was evident, and some space was being carved up in new ways.

In the Midwest and East, large suburban lots designed around the lawn are common. Changing them is difficult, since four acres of rock garden makes a house look like it is in the middle of a quarry. Two other options are natural grasses, often in combination with wildflowers, and broad-based coniferous trees and bushes. Natural grasses are also being used in the public domain, along highway berms and in some parks. It remains to be seen, however, if Americans will desire as much space between buildings when it is designed to be wild instead of tame.

Space in Downtown Plazas

Even though American downtown areas are generally very open and spacious by world standards, they have long been criticized for being too congested and having too little light and air. From the City Beautiful Movement of the 1890s through the urban renewal projects of the 1950s and 1960s, architects and planners sought to remedy the situation by adding vast amounts of open space. Many cities instituted planning guidelines and zoning requirements aimed at encouraging the creation of open plazas around downtown buildings. Floor area

ratios were established that related total volume of allowable space to the size of the lot. For example, a ratio of ten to one would make it possible to construct a ten-story building covering the entire lot, a twenty story building covering half of the lot, or any other combination that resulted in ten times the floor space of the lot. Thus, corporations planning to build a monumental skyscraper often obtained a large lot but used only a portion of it for the structure itself, allowing the rest to become a plaza. In some cases, cities awarded zoning bonuses in the form of additional allowable space if certain amenities like fountains, gardens, trees, or benches were included in these semipublic plazas. The goal was to create a Corbusian city of "skyscrapers in a park," and most builders eagerly cooperated. During the 1960s, over one million square feet of plaza space was created in Manhattan alone as new towers replaced older buildings, and the practice became common from Boston to Los Angeles. Traditional urban street walls disappeared as buildings were set further and further from the sidewalk. Some American downtown areas became so open that they no longer functioned well as central business districts.

While at first the new plazas were greatly appreciated because of their scarcity, plaza redundancy soon became a problem in many downtown districts and suburban office parks. When a street is literally lined with plazas, as in the case of New York's Avenue of the Americas, open space can become excessive and unappreciated. When open plazas are built adjacent to other open plazas, what can be used to fill all of the space? Some minimalist plazas consist of nothing more than plain or decorative paving and are hardly distinguishable from surrounding sidewalks. Others are filled with vegetation, usually planters or raised gardens. In some cases, such as at the Nationwide complex in Columbus, Ohio, and at Seattle's Freeway

Park, downtown plazas have become dense jungles (at least in the summer) as vegetation has matured. In other places, such as Boston's Back Bay, it is not uncommon to find grass lawns with trees several floors above the street.

While the idea of creating plazas originally had been linked to the need for more usable public or semipublic open space, many plaza owners have mixed feelings about attracting people to the settings they control. On the one hand, a popular plaza can bring fame and prestige to a building if it draws the elite, but, on the other hand, if the plaza becomes a hangout for a less desirable crowd it can detract from a building's appearance. In downtown planning, the field-and-stream look of dense vegetation, ponds, and dark pathways has its downsides. There are legal complications associated with the creation of possible forest hideouts for drug-dealers or muggers. In a litigious society, there is also the threat that interesting fountains and vegetation might lead to accidental injuries and lawsuits. In New York City, for instance, at the World Trade Center, a wind tunnel created by tall buildings damaged nearby windows and caused passersby to be doused by decorative fountains.

The trend in recent years has been to recapture some of the space once reserved for plazas and use it for street-level commercial activity. The tower-in-a-plaza format greatly diminishes the number of street-level doors and, consequently, street-level retail and service establishments. This, in turn, reduces the usability of open plazas. Only rarely do people use the spaces around the new buildings, as there are no cafes or shops associated with them. Even nicely designed spaces are often perceived to be lifeless and boring if there is nothing to eat or buy. You cannot window-shop at a bank lobby. Gradually drink stands, hot dog vendors, and flower stalls began to invade the plazas, and soon sidewalk cafes and glass-covered arcades ap-

peared. Recently, zoning bonuses and other rewards have become available to new developments that include a traditional streetwall with multiple doors leading to cafes and retail outlets. We seem to have come full circle, but vegetation remains an important component of the new, livelier designs.

Fragments of Anonymous Space

So far I have concentrated on the *designed* spaces between buildings, such as lawns, gardens, and plazas. Many of the spaces in American cities, however, are not designed at all but rather are fragments of leftover, unloved, uncared-for, anonymous space. Grady Clay, in *Close-up: How to Read the American City* has referred to these as *frags*—geographic design errors that leave useless slots of space between buildings, parking lots, and fences, inevitably inviting trash dumpers. Such leftover slivers sometimes degrade to become *sinks* or *stacks*. *Sinks* are relatively hidden foci of refuse, akin to swamps or dumps, while *stacks* are places where various materials tend to pile up. A walk around almost any American downtown area or commercial strip will lead to back lots with stacked pipes or strewn garbage and other examples of all three landscapes—often in the same location. Behind and between the facades of urban America, back lots—frags, sinks, and stacks—come in all shapes and sizes.

Fragments of space are common in American cities for a variety of historical reasons. Most obvious among them would be that relatively few buildings were designed to cover their entire lot. Also, American cities developed lightly initially, with backyards for storage instead of the interior courtyards found in much of the rest of the world. Most American buildings were rectangular or at least consisted of a box with rectangular additions, regardless of setting. Unlike in many older European cities, where building mass was made to fit the lot, the Ameri-

can "box" often did not conform to curving or otherwise irregular street patterns. Indeed, the triangular Flatiron Building in New York City (1902) was thought to be highly unusual because it was not rectangular and it fits its lot. The siting of American buildings is sometimes the architectural equivalent of placing square pegs in round holes. As a result, the sometimes awkward and ragged spaces between cannot easily be used or even categorized.

With the introduction of fire codes and required setbacks at the fronts and sides of many lots, the frag situation became more pronounced. Spaces were required in order to separate buildings rather than to accommodate particular uses. As a result, many spaces too small or too dark to be used effectively were ignored. Later, as vehicular traffic increased and suburbia exploded, many setbacks were aimed at isolating buildings from noisy and dangerous highways, with pedestrian-unfriendly zones of grass, mud, and stones lining the edges of commercial and residential lots on busy thoroughfares. While the most striking examples of spatial frags are those at the extremes—small and dark or open and bleak, there are many examples between the two, from dirt lots with parked trucks to awkward spaces along alleys or under billboards and overhead freeways. On ragged commercial strips, roll-out electric arrow signs and other makeshift displays fill the spaces. These are the things that people are most likely to notice in a hurried, automobile-centered world. Where no one walks, many spaces are reduced to invisible or at least blurry interludes. No one is in charge of caring for them.

Buildings in American cities tend to be separated by lots of space, and there just isn't enough care to go around. Both private residents and the city policymakers ignore curbside spaces between sidewalk and street, which become "no one's land."

Oddly shaped buildings or buildings placed on oddly shaped lots often result in peculiar leftover spaces in which monstrous weeds become the predominant vegetation. While most frags, sinks, and stacks tend to be fairly small in area, they can loom large in our image of a city: even when individual buildings are beautiful and well-maintained, unattended frags can dilute their impact. American cities have scads of such underutilized spaces. It is as if we need mortar to fill the cracks in the cityscape.

In a few areas, residents take great pride in the purposeful nurturing of yards resembling frags and stacks. Such neighborhoods have been described as "libertarian suburbs" and, while usually associated with lower-income groups, actually represent a fairly wide range of social classes. These are Americans who bristle at the idea of anyone telling them how their property should be used or designed. Unkempt bushes and makeshift sheds abound. Residents may view a pile of bailing wire or a rusting truck on blocks as icons of hardy independence. Used appliances may also be "stored" in the yard along with stacks of building materials and a kennel or two. These spaces bring to mind a rougher—but perhaps more authentic—kind of rustic heritage than does the lawn. On the other hand, if lawns really do become too expensive and environmentally unsound, unkempt frags may become increasingly common.

The Urban Forest, or Shades of Things to Come

Flying over a typical, middle-sized American metropolitan area in the summer, one can barely see the city for the trees. Urban forests have taken over many of the spaces between buildings, at least in residential areas. In most downtown areas, however, trees, when they are present at all, seem to have been added on a random basis even though they are usually featured in urban design plans. Each year, trees are planted on one street

as part of a much-ballyhooed beautification scheme and re-moved from another because of concerns over buckling side-walks or excessive leaf debris. Still, trees play a very important role in filling gaps in the urban fabric and softening the effect of some otherwise brutal architecture.

Like grass, trees are thought to have a soothing effect on har-ried urban dwellers, but the effect is often uneven. In some cases, trees are important in establishing the overall character of a place, while in other situations, they are scarcely noticed. In some settings, they are planted in a formal and regular way to enhance a sense of perspective (sometimes in conjunction with focused revitalization efforts), while in others, they are arranged to promote a natural, rustic ambiance. In North America, trees are emphasized in most urban design plans, but it is not always clear why. It may be that trees are sometimes used simply to hide or soften otherwise banal buildings, while, in other cases, they may be used to give personality and char-acter to a street or to heighten and celebrate the passage of seasons by displaying fall colors or providing cherry blossoms each year.

The practice of planting trees in cities began in the Low Countries during the late sixteenth or early seventeenth cen-turies. Trees were first planted along the tops of the *boulevarts* (boulevards)—wide, earth-filled city walls—in Antwerp as early as the 1580s, creating shady, elevated promenades. Amsterdam used trees to shade and decorate its canals as the city expanded during the early decades of the seventeenth century. The idea of using trees to enhance urban space gradually spread to other cities in the Low Countries, but they were planted only in spe-cial places. Trees were generally absent on average, workaday streets. Elsewhere in urban Europe, trees were also used spar-ingly, if at all, during the seventeenth and eighteenth centuries,

especially in poorer regions, where they likely would have been snapped up for fuel or building material. While trees were a part of the ancient enclosed-garden tradition in Italy, they were very rarely seen on its narrow and winding streets or even on its new Baroque boulevards. In France, trees were featured prominently in the design of the new courts, malls, and promenades but were largely absent from lesser urban streets. Even today, the arteries of central Paris can be divided into two distinct categories—grand avenues lined with trees and small treeless streets.

The first use of trees to line streets probably occurred beyond the boundaries of cities. Particularly in France, trees were used to line important highways like those leading from Paris to country chateaus or religious establishments. Gradually, the idea of using trees to create grand entries to the gates of the city evolved. The French also adopted the Dutch practice of planting trees on top of earthen ramparts or *boulevards* and using them for promenades. Garden promenades or malls were important in seventeenth century Paris as well, especially in the Tuileries, where Paris pioneered the development of shady *allées* for carriage riding. Eventually, all of these practices began to merge as Paris became the center for urban design innovations in the eighteenth century. The idea of an interior, tree-lined boulevard took shape as the Tuileries promenade was extended through a field, the Champs Élysées, which later gave the new boulevard its name. By the late eighteenth century, the concept was fully developed and had begun to diffuse into other parts of Europe.

The British followed a somewhat different aesthetic plan. Beginning in the seventeenth century, the expansion of London involved the construction of green residential squares. These squares were thought necessary to provide an attractive desti-

nation for potential residents of the newly developing suburban estates. Unlike the paved piazzas and plazas common to Mediterranean Europe, English squares were filled with vegetation. During the seventeenth century, formal gardens were in vogue, but by the late eighteenth century, the rustic, natural look of trees and grass had become standard. During the eighteenth and nineteenth centuries, many royal hunting grounds and other private preserves near the city were converted to public parks. London gradually became a green city of miniforests. Other English cities followed suit, and a preference for foliage became an important landscape taste. Street trees, however, remained rare in English cities. France had tree-lined boulevards, while England had leafy parks. It was the English tradition that was imported to the United States during the nineteenth century.

Early paintings and photographs of New York and Boston show them to be nearly devoid of street trees, but trees were important and highly visible features in planned open spaces. In Boston, for example, both the small private parks like Louisburg Square and the large public parks like the Boston Common were full of trees by the mid-nineteenth century. So too was the median strip of Commonwealth Avenue in the newly created Back Bay—a cross between a linear park and a shady boulevard. In New York City, Central Park was laid out in the 1860s to be a sort of natural, open forest. Trees were thought to provide a valuable source of fresh air that could ward off the dangerous miasma of the city. For this reason, green parks became associated with health in the American city, and many were created as much for this reason as for aesthetic enjoyment.

Aside from their use in parks, trees in nineteenth-century American cities were a kind of random and occasional feature planted here and there in the spaces between buildings. As

early as the 1880s, some New York City residents pushed for street trees, arguing they would cool the city and cut down on epidemics. The response was slow. In outlying suburban areas, trees were already becoming common by the 1880s, but they were most often planted in private yards rather than as part of the public parkway. Deep front yards seemed to cry out for a shade tree or two. No formal or regular location for trees existed in most nineteenth century neighborhoods. American city planners lacked the kind of authoritarian urge for monumentality that had led to the creation of the Champs Élysées in Paris or the Unter den Linden in Berlin. Indeed, even the grand spaces envisioned for Washington, D.C., were painfully slow to take shape. In most cities, trees were thought to be a completely private issue. Putting trees on public thoroughfares involved using tax money not only for the initial planting but also for continued maintenance and cleanup. Moreover, with the coming of electricity, the air space above the street was soon filled with a tangle of wires and telephone polls. Trees had to wait.

The Role of Trees in the Contrasting Image of City and Suburb

Until quite recently, the commercial centers of North American cities have tended to be devoid of vegetation. Sidewalks were narrow and congested, especially where street widening projects had occurred, and advertising signs often took up the available space. Lacking the grand boulevards and authoritarian design ideologies of European or even some Latin American cities, downtown areas in America were devoted to making money. The business of America was business. Skyscrapers could dwarf the mightiest of trees. Even in relatively monumental capital cities, trees were usually confined to the state-

house grounds or, in Washington, D.C., the Mall. Where street trees were planted, they were often short-lived. The combination of pollution, street widening, constant new construction, the addition of transportation and utility infrastructure, the need for basements and service elevators under sidewalks, and a low priority for the maintenance of primarily aesthetic embellishments meant that most commercial centers were treeless through much of the twentieth century.

In suburban residential areas, things were quite different. People planted trees where front yard setbacks and green parkways between the sidewalk and the street existed. While Anglo-American society had long been characterized by a strong preference for trees, their planting and maintenance tended to be very individualistic. Seldom were identical types of trees planted in uniform, orderly arrangements over large territories, as had been the tradition in much of Europe. Rather, random suburban forests evolved, often with several widely varying species on one lot. Maples, conifers, and weeping willows competed for attention with Tudor cottages and Spanish haciendas. Diversity and even vegetative chaos were common, but suburbs were, above all, green. In the autumn, streets were often covered over with downed leaves and, before the environmental regulations of the 1950s and 1960s, the smell of bonfires filled the air.

The contrasts between the commercial city center and the residential suburb were perhaps greater in North America than anywhere else in the world, and this contrast has played an important role in the image of the North American city. In southern Europe, for example, there were normally few trees in either the city center or the suburbs, and in Paris, Madrid, and Vienna, grand streets had trees while small streets did not, regardless of whether they were primarily commercial or resi-

dential. In much of Europe, suburban areas contained high-rise apartments by the 1950s, while in Latin America suburban areas often included many treeless squatter settlements. Similarly, there was little room for trees in the major cities or suburbs of Asia. In North America and, to a much lesser extent, England, the contrast between the treeless center and the forested periphery is extreme. This contrast has colored our perceptions of the two types of areas in many ways.

Cities, specifically their commercial cores, are seen as bleak, gray, hot, glaring, gritty, and hard. Suburbs are green, shady, clean, cool, and soft. Many of our urban stereotypes reflect these contrasts and influence residential and other location decisions. Indeed, many of the derisive comments aimed at postwar tract developments had to do with the numbers of look-alike houses plopped onto barren, treeless plains. As the trees matured, the criticism receded. In a society that puts a high value on trees, a green neighborhood is a desirable destination.

The greening of the suburbs has not been without its ups and downs. In many areas, inappropriate assemblages of trees were planted and the goal of leafy serenity was not achieved. In addition to Dutch elm disease and chestnut blight, trees have also faced negative reactions from people for a variety of reasons. Tree roots invade sewer lines and destroy sidewalks and patios, while branches can grow into high-tension utility wires and sometimes cause fires. Residents rush to plant trees, but they often make big mistakes in the process. A few years later, there may be massive attempts at neighborhood deforestation as people tire of the mess and maintenance of poorly chosen street trees.

Some trees are more trouble than others. Certain types of trees may drop leaves, branches, berries, and sap in such incredible amounts that they cause damage to cars and other

property. Tree-loving birds often target the people, cars, and sidewalks below them as well. When tree limbs hang over a property line, offending trees often get axed. In California, the fast-growing Australian Eucalyptus tree once was planted in great numbers, but it has since left quite a few people unhappy. The wind easily scatters Eucalyptus leaves into pools and spas, and the trees have shallow roots and sometimes blow over in high winds. Many housing tracts have reverted to barren plains, as downed trees have not been replaced.

In recent decades, a variety of neighborhood organizations and city advisory agencies have arisen to attempt to bring order to the suburban forest. In some cases, the city will pay all or part of the cost of trees if volunteer groups will organize planting parties. In this way, entire streets become tree-lined at one time and mistakes in tree siting and selection are minimized.

Downtown Trees and Urban Design

Are street trees a good idea in central areas of large North American cities? Is there enough space for trees downtown? Nearly every city pays lip service to the desirability of trees, but in reality cities are diverging in their level of leafiness. Some cities have made major attempts to create a continuous canopy of green throughout their downtown areas, while others have experienced substantial tree attrition due to slashed maintenance budgets. Portland, Oregon, and Sacramento, California, on one hand, now have deciduous trees throughout their commercial cores. In summer, they provide a dense, shady canopy and a sense of enclosure. This is especially important in Sacramento, where summer temperatures can reach 110° F. In winter, after the leaves fall, sunshine hits the street. In cities where street trees have been planted in great numbers, the perceived contrast between city and suburb has been diminished. In both

Portland and Sacramento, the several neighborhoods in and around downtown are considered relatively attractive places for work, recreation, and residences. Obviously trees do not solve social and economic problems, but they can blur boundaries and soften geographic distinctions.

In New York City, on the other hand, concerns have arisen that street trees are becoming an endangered species. Over the past few years, more than twice as many street trees have died as have been planted. Air pollution, compacted soil, dog urine, cleaning chemicals, vandalism, and storms have all taken a toll in New York City, as in many other places. Scarce budgeting for tree maintenance, a low priority in times of fiscal crises, combined with concerns about liability from falling branches and uprooted sidewalks, has diminished enthusiasm for planting street trees. As a result, opposing trends coexist. Some downtowns are becoming greener, while others are not.

Trees help turn spaces into places. Even when a street's architecture or service functions are similar or nondescript, streets can be given unique identities through the presence of different trees. Elm Street is quite different than Palm Street or Spruce Street. Place personality can also be enhanced through an emphasis on seasonal variations. Trees that yield, in the course of a year, new sprigs and leaves, blossoms, fruits, leaves of varying colors, and bare branches, highlight the passing of seasons and add to temporal legibility. Varying fragrances from blossoms or decaying leaves can add to the sense of place. Trees create a colorful ceiling for the street as civic space. Their costs may be high, however. Maintenance of street trees requires a considerable commitment from cities. They can drop litter and debris, hide signs, and intrude into architectural and utility space. The result of halfway upkeep is scraggly remnants

that add little to the urban scene. Trees must be given the space they require.

Vegetation and Space as a Circular Issue

Do we create space for vegetation, or do we use vegetation to fill the various spaces that have evolved over the years? Do we separate houses and office buildings because we desire vast lawns and a canopy of trees, or do we simply find it easier to build separate, free-standing structures and then use grass and bushes to fill up the gaps? Do we have required setbacks in order to minimize traffic noise and to ensure adequate light and air, or do we demand setbacks for a front lawn? In some settings, we seem determined to cram as much beloved vegetation as possible into tiny corners, while other, larger areas go unloved and unwatered. Do we design spaces to accommodate vegetation even when the occupants cannot afford to maintain it or simply do not want it? The issue is complex, and the inertia that results from longstanding building traditions and institutionalized regulations plays no small part in the landscapes we are still creating today. As we ponder the various types of spaces between buildings, however, the topic of vegetation may help us to interpret our deeper motives. Why is it that we create the spaces that we do?

These issues have to do with measuring the quality of life in cities. We have often assumed that when it comes to open space and green vegetation, more is always better—a logical reaction to the perceived congestion of many nineteenth-century industrial cities. Today, however, problems often result from the existence of too much space. As the environmental problems associated with using massive amounts of water, chemicals, and fertilizer for green lawns worsen and as the inconven-

ience of having to use automobiles to travel between buildings in the same commercial or residential complex becomes apparent, we are beginning rethink some of our place-making policies.

It may be that Paris (or London, or San Francisco, or other dense but livable cities) was right. Diversity is the key to providing interesting spaces with well-tended vegetation. Small, treeless lanes can be used in combination with grand, tree-lined boulevards. Green parks or squares can be lined with townhouses built flush to the street. Well-manicured lawns might be accessible but not ubiquitous. Street trees can be used selectively to give identity and character to particular types of settings—some designed for maximum shade and others for sun. In the end, a few well-cared-for spaces with luxuriant vegetation may be more appreciated than vast, marginally-tended areas with scruffy bushes and patchy grass.

Vegetation and the spaces it occupies can be thought of as architecture in their own right. Such areas may be thought of as supplying potential themes, landmarks, and a heightened sense of the passage of time to particular neighborhoods and places. Various levels of enclosure can be accomplished by using royal palms, oaks, hedges, and roses. Just as buildings surround and define good urban spaces, so too does vegetation. Just as buildings can be decorated for seasonal holidays and festivals, so too can trees be selected to heighten the sense of season with color and blossoms. Properly designed green spaces can enhance the vitality of lively city scenes or provide quiet refuges from them, but scale is important. After all, cities are not rural areas. Good cities are defined by access and connectivity, the ease with which one can go from one activity to another with a minimum of unpleasant obstacles. To the degree that green spaces and other vegetation enhances the urban ex-

perience, they are beneficial. To the degree that they dilute urban life and impose barriers to easy interaction, they are problematic. As we peruse the urban scene, we might occasionally try to differentiate between truly advantageous green spaces and those that simply get in the way.

|| Shapers of Space

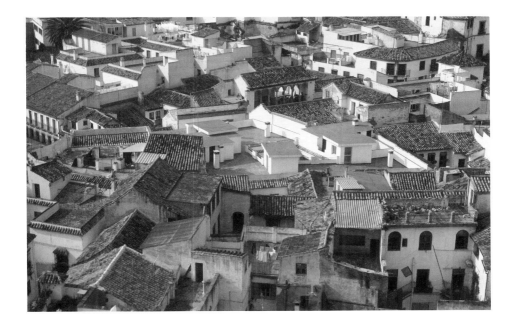

In Cordoba, an old Moorish city in Spain, vestiges of a confined medieval urban space dominate the landscape. Here there is little space between buildings and no clear-cut indication of where a street begins and ends. There is very little room for vegetation except in private courtyards.

In the new corporate American landscape, such as Constitution
Plaza in Hartford, Connecticut, isolated buildings awash in space
are united (in theory) by a landscape architecture of trees, planters,
and walkways. Do we crave space for vegetation or do we use vege-
tation to fill the vast spaces we create?

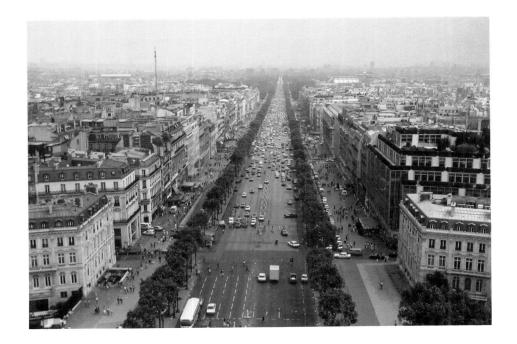

The famous tree-lined boulevards of Paris's baroque city plan offer
residents a new perspective of space and access that radiates out-
ward toward the country from the center of the city. This plan was
repeated in Washington, D.C., and other cities seeking to create
monumental "great streets."

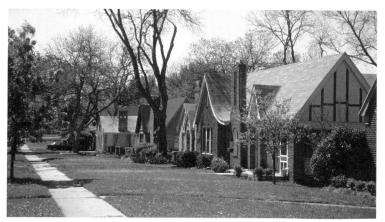

Top: In Savannah, Georgia, a planned eighteenth-century community, the shapers of space are the public squares that organize the city's grid. Recent preservation efforts embellish this idea, and green squares have become highly desirable foci for gentrification. *Bottom:* A continuous swath of front lawns in front of timber-frame houses enhances an "English" landscape ideal in Fort Worth, Texas. Such imported landscape aesthetics often involve a combination of hybrid grasses and period revival architecture.

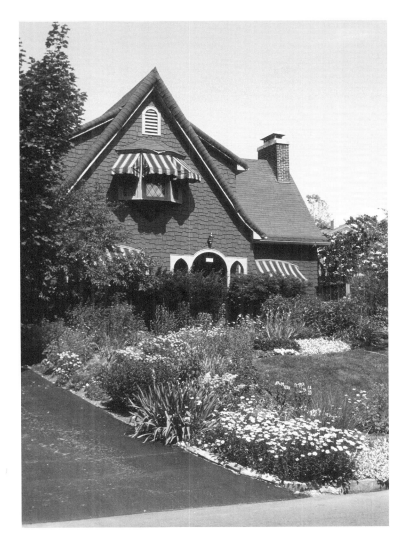

A "natural" front yard of flowers, shrubs, and grasses adorns this attractive house in Columbus, Ohio. While lawn alternatives are catching on fastest in the arid West, landscape architects and gardeners are creating new yard types in other regions as well.

Top: A low-maintenance desert landscape embellishes this front yard in San Diego. With the area's scarce and expensive water supply and plenty of sunny days, some Californians have switched from a Northeastern to a Southwestern homescape aesthetic. *Bottom:* This San Diego homeowner is the first on the block to convert a grass lawn to a flower garden. Once the sweeping, uniform front lawn look is broken in a particular neighborhood, those nearby are more likely to make the change.

This homeowner uses a "privacy fence" to define and enclose part of the front yard for a patio in San Diego. As lots get smaller and houses get bigger in some high-cost locations, people are reclaiming the open front yard for more intensive activities.

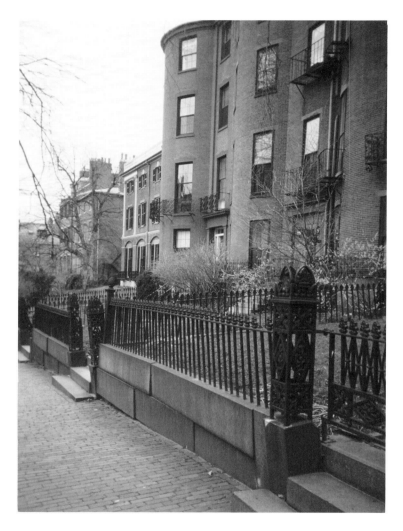

Decorative wrought iron fences and gates enclose small front yards in Beacon Hill, Boston. Uniform fencing can be used to enhance architectural coherence, but when both house facades and fencetypes are all different, the result can be an aesthetic jumble.

Front yard fences are common in many neighborhoods in Orange County, California. For a variety of cultural and functional reasons, people in Latino neighborhoods sometimes compete to have the fanciest fence or gate on the block.

Top: Backyards in Levittown, Pennsylvania, are traditionally open and unfenced, but patio enclosures are beginning to appear. As families have aged and gotten smaller, the lawn as "play space" has sometimes been enhanced with decks and other settings for more sedate activities. *Bottom:* The vertical symmetry of trees dominates the horizontal feel of a residential street in San Diego. When houses are low-slung and set back from the street, trees can help to create a sense of identity and enclosure in a neighborhood.

A formal line of trees dresses up a pedestrian street in Pioneer
Square in downtown Seattle, Washington. A canopy of green
makes streets cool and shady in summer while autumn leaves and
bare branches help accentuate and celebrate seasonal change.

This front yard is used as a religious shrine in a Portuguese Azoran neighborhood in Toronto, Canada. Recent immigrants sometimes do not share the Anglo-American preference for decorative lawns. Vegetable gardens and religious statues may be seen as better uses of valuable space.

Street trees, hedges, and other landscape features integrate well with the architecture in downtown Portland, Oregon. Vegetation can reinforce a strong sense of place identity when used in combination with other symbols.

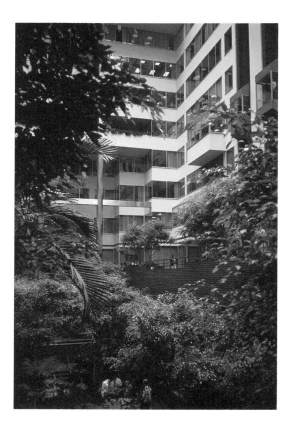

Trees and shrubs shape the interior space of an office atrium in Philadelphia. Since much of urban life has been internalized into malls and atria, it makes sense that some of the vegetation we desire has moved inside as well.

THREE || Spaces for Driving, Strolling, and Parking

Until the eighteenth century, most of the spaces between urban buildings were multipurpose and vaguely defined. With the rise of the Industrial Revolution, however, specialized spaces began to take shape. Among the most important are those designed for pedestrians and vehicles and, eventually, for the storage of the machinery of transportation. This essay discusses spaces for movement and storage, from the porte-cochere of eighteenth-century Paris to the three-car garage of contemporary America, as well as the street systems and pedestrian ways that have shaped movement in cities, from the advent of the sidewalk to the current controversies over street grids versus cul-de-sacs. I begin with the design of individual buildings and the spaces around them and work outward toward the alley, sidewalk, and street.

Room for the Carriage

Before the early decades of the twentieth century, very few urban buildings included adjoining spaces for either the short- or long-term parking of vehicles. The antecedents of modern parking spaces, however, go back to at least the seventeenth

century. In Europe centrally located palaces like those in Paris or Vienna had courtyards that included a circular driveway so that coaches could enter a gated compound and drop off occupants in relative security and comfort. The coach was then driven off for storage elsewhere. These porte-cocheres were rare, as only the elite could afford such a liberal use of expensive urban land. Porte-cocheres required not only financial power but political status as well. For a time, only the nobility could have what it wanted.

Not as common in urban America, a few porte-cocheres appeared with the advent of luxury hotels and apartment buildings in the later years of the nineteenth century. But with the arrival of the automobile, vehicular space became an important consideration. Before World War I, the hitching post and the extra-wide downtown street or square were about as far as American builders went to accommodate parking. For the most part, horses and carriages were kept in neighborhood stables well-removed from occupied houses and offices. Servants could be relied upon to bring the carriage around for those who could afford such a luxury—a very small minority of urban dwellers. In some suburban areas, with spacious grounds, separate carriage houses, forerunners of the twentieth-century garage, could be found toward the back of the lot. Houses rarely had any vehicular space until well into the twentieth century. The spaces around and between houses were for people— front porches, grand stairways or stoops, primrose lanes, and picket fences.

The Residential Garage

The residential garage appeared with the widespread use of the automobile during the early 1920s. For a time garages and alleys went hand-in-hand. Just as the carriage house was per-

ceived as a potentially dirty, smelly, and noisy place that was best located as far as possible from the house, so too was the early garage. After all, the automobile was a machine that involved smoke, grease, oil, backfiring, and the storage of toxic materials. Like horses and servants before them, automobiles were relegated to separate realms and separate egresses. They had to come and go via the alley.

Alleys were not common during the earliest platting of American towns and cities. They were not the rule, for example, in Manhattan or central Boston. As in Europe, the rubbish of day-to-day living was temporarily stored in interior courts, which could be hidden from view with heavy doors. As the nineteenth century progressed, however, the need for alleys became evident, and, in many cities, they were carved into the original blocks around midcentury. While the need for storage and delivery space was the most common reason for creating alleys in business districts, the need for vehicular storage space was the main reason for creating alleys in residential areas. By the late nineteenth century, alleys were a common feature on the American urban scene.

The number of residential garages lining alleys exploded during the early years of the twentieth century, especially as Sears and other large retailers began selling prefabricated garage kits. They were usually constructed on the back of lots with doors facing an alley. In residential areas of row houses, alleys were the only possible location for a garage. Alleys were also functional for providing access to a sometimes messy back yard; few advocated hauling trash out through the living room. In neighborhoods where houses were built as double- or single-family structures, however, the need for alleys was less pronounced, since side paths were possible. Still, they remained the norm until about 1940.

THE SPACES BETWEEN BUILDINGS

Alleys became common in downtown regions as well. In business districts, large, multilevel parking garages were initially situated in alleys in order to avoid disrupting the commercial life of the street. In neighborhoods where houses had been converted into commercial establishments, surface parking was often placed behind buildings in what had once been the back yard. In all but the largest cities, the amount of space between buildings increased during the 1920s as people sought to make room for the car.

Alleys began to change, however, during the late 1930s. Exposés of long-suspect alley housing and back courts confirmed the horrible conditions that sometimes prevailed when poor people lived out of sight, out of mind. Depression-era photographs of alley housing in the shadow of the Capitol in Washington, D.C., shocked the nation. Although the alleys in Washington had been created during the 1850s in order to provide a place for low-cost housing for servants and laborers, after the Civil War, many of them became minighettos. The Depression only made things worse. Plans were made to diminish the importance of alley housing in all American cities and, by association, the worst slums. When the federal government got involved with urban renewal, public housing programs, and FHA loans during the 1930s, officials usually disallowed alleys. Large public housing projects consequently featured superblocks with few streets, let alone alleys, and alleys were eliminated from most new suburban housing projects as well. People seeking government-backed mortgages were encouraged to locate in alley-free neighborhoods.

By the late 1930s, alleys were rarely built, so the garage, still located at the back of the typical long, narrow residential lot, turned to face the street. Narrow, paved or macadam driveways passed by the sides of houses to the garages at the rear. Soon,

SPACES FOR DRIVING, STROLLING, AND PARKING

garages began to creep forward in builders' new lots, which required dressing up the structures. As they were built closer to houses, garages adopted compatible architecture and detailing. Simple, functional sheds were no longer acceptable, and by the late 1930s houses and garages were often clearly built as a matched set. For the first time, a landscape of vehicular storage and movement, both the garage and front driveway, came to be an aesthetically pleasing status symbol in middle-class American neighborhoods. Not yet dominant, it was visible all the same.

During the late 1940s, the garage pulled even with the house. No longer confined to the back of the lot, the garage, or in more modest neighborhoods the covered carport, now sat next to the house, close to the street for several reasons. First, lots became wider and less deep as the aesthetic of the side-gabled ranch replaced the traditional narrow urban house. Second, garages were incorporated into the design of these houses with the goal of making them appear larger and more prestigious. Indeed, very often the garage served as an immediate way to add a room, as many were converted to extra bedrooms. By the 1950s, with two- and three-car garages built under the rooflines of houses, even modest homes could appear substantial. Third, backyards were now thought of more as recreational zones complete with swimming pools, barbecue pits, and patios, so the back garage was moved forward on the lot to get it out of the way. Fourth, the high costs of paving a long driveway, especially a multilane driveway, made it more cost-effective to locate garages close to the street. Front setbacks also gradually diminished because sewer and utility lines could be shortened with the house nearer to the street. Fifth, new kinds of trash containers meant that garbage cans could now line the street for trash pickup, without detracting too much from the neigh-

borhoods' appearance. Finally, garages and cars were increasingly thought of as safe and clean. For better or worse, revving up the car engine right next to the kitchen no longer seemed uncivilized.

The Garage-Dominant Landscape

As long as the one-car garage was standard during the late 1940s and early 1950s, the look and feel of most neighborhoods was not greatly affected by the new spatial arrangement. Driveways were narrow, garage doors small, and most households had only one car. As the 1950s wore on, however, vehicular space became increasingly dominant. Both garage doors and driveways widened, often encompassing half the total width of the house. As cars became longer and more numerous and driveways shortened, tail fins and exhaust pipes commonly intruded into sidewalk space. Strolling pedestrians faced the ritual of constantly walking around vehicles.

By the late 1960s, the garage and driveway began to dominate the suburban scene. In areas where residential land was scarce and expensive, such as California, lots shrunk even as houses swelled, forcing garages to the front and thereby causing the residential facade and front yard to all but disappear. The two-story house regained popularity, but since much of the first floor was given over to garage space, average house size increased, in part, to allow for necessary interior stairways. Households with two and three cars and no alleys needed expansive on-site parking space, as driveway entrances now usurped former curbside spots. This created some very real aesthetic concerns. When 60-80 percent of a residential facade consists of garage doors, it is difficult to design a picturesque house with what is left. In addition, when the massive garage doors are open, the house looks a bit like an airplane hangar. If

garages become storage areas or workshops (with no room for a car), as can happen in homes lacking attics and basements, suburbia becomes a landscape of welders and furniture-strippers surrounded by an army of cars when doors are open. An entire neighborhood of such houses can look like a combination of a car lot and swap meet. The pretty landscapes are all out back—a complete reversal of the traditional urban aesthetic, in which the facade is all-important.

This new landscape is often directly related to city codes and zoning ordinances. With alleys disallowed and off-street parking required even on small lots, there was bound to be trouble when auto ownership skyrocketed. The reaction to the increasing numbers of automobiles, however, is usually to facilitate the creation of an even more auto-dominant landscape through the use of stricter zoning or, more recently, homeowners' associations with obligatory codes, covenants, and restrictions. In many newer developments, on-street parking has been eliminated or greatly restricted—often a necessity when driveways take up most of the street frontage or when houses are built around a cul-de-sac. In addition, community rules now stipulate how long garage doors can be open, how long garbage containers can be set out, what kinds of vehicles can be visible (cars versus trucks, campers, and so on), as well as what kinds of vegetation and house color schemes are permissible. The irony is that these new rules are necessary because the old rules prohibited alleys and back garages. Consequently, the suburban residential street is now mainly a vehicular landscape made up of endless garage doors and driveways. Defining, shaping, and controlling the aesthetics of this landscape can be a major job. After working long hours, residents must still find time for homeowners' association meetings to deal with garage and driveway issues.

THE SPACES BETWEEN BUILDINGS

The vehicle problem is especially acute with multifamily housing units constructed in older residential areas that have no alley access. In neighborhoods with alleys, it is usually possible to build garden apartments or bungalow courts with parking on the first level of a two-story rear complex. Where no alleys exist, the front "yard" serves as a parking lot. When several such apartment buildings are on the same street, the entire block becomes head-in parking and sidewalks become bleak and dangerous. Children, the elderly, and the physically handicapped no longer have a place on the sidewalk because they may have trouble dodging the cars pulling into and backing out over it. With ubiquitous driveways, traditional on-street parking becomes impossible, so more and more off-street parking is required, usually one or two spaces per housing unit. Ironically, allowable residential densities are most often determined by parking requirements, which then prevents the development of the threshold populations needed for mass transit and pedestrian-oriented stores and services. Thus neighborhoods become dense but still lack urban amenities.

In San Diego, an urban design task force established during the 1980s has found limited remedies for the problem of residential street parking. One proposal forwarded would allow no more than half a lot's frontage for parking, requiring the other half to have some sort of garden, patio, or pedestrian walkway. (As it is now, people visiting a typical infilled apartment complex on foot must thread their way through parked cars to gain access to a door.) Cars would be put in the alleys where possible or in a tandem arrangement on the side of the lot. Building facades would also have to be less vehicle-oriented in design, that is, not a row of garage doors or first-level parking. In another proposal, the number of required parking spaces per unit would be diminished to encourage city residents to have fewer

cars. So far, the impact of such proposals has been limited, and in California the growth of parking landscapes in older residential areas perceptually deteriorates neighborhoods.

In newer, larger apartment complexes, the problems are different. In big, centrally located buildings, underground parking is usually included. While limited access to the garage can diminish the number of driveways, the streetscape is not always much better for it. Blank garage walls that take up half of a block can be covered with ivy, but visual interest is usually minimal. In suburban apartment complexes, individual buildings are often surrounded by acres of parking, interrupted here and there by an island of grass or trees. Clustered parking, with more space given over to green walkways and gardens, requires people to walk further to get to their automobiles, which can make them nervous and unhappy. Profitable apartment sales and rentals often require that tenants be close to their cars.

Where to locate parking, driveways, and access ramps is an even a bigger problem in downtown commercial areas. For the first few decades of automobile use, small lots on the edges of commercial cores were cleared for surface parking. Underground parking and parking garages were rare things before World War II, but by the late 1940s and early 1950s, large parking structures had become a big city necessity. Owners of department stores and large office buildings purchased adjacent properties and leveled them for multistory garages. As in residential areas, access was sometimes a problem. Large garages needed several ways in and out, so alleys were utilized. As usage increased, however, traveling very far in a narrow alley became difficult and dangerous. Soon corner lots with several street entrances were in demand for garages. Some of the highest-visibility, most prestigious corners in American cities came to be dominated by parking ramps and signs. Still, the options

were limited. Where alleys or other streets could not be used as entryways, long stretches of prime commercial streets were dominated by garage entries, and sidewalks became ramps to garages. The number of pedestrian-oriented, street-level doors plummeted. Even when garages were well-designed or, as in recent years, when older commercial buildings were gutted and converted to parking, their impact on sidewalk and street front space was immense.

The Value of Alleys

There have been surprisingly few studies of American alleys. Grady Clay's look at the alleys of Louisville and James Borchert's study of alley housing in Washington, D.C., stand out as exceptions. There is little doubt, however, that some very interesting things are going on in urban alleys. In San Francisco, a number of tiny downtown alleys have been filled with flower shops, pubs, delis, and business service establishments. In Columbus, Ohio, a small alley running just behind the major office street provides a makeshift pedestrian mall with several lunchtime hangouts. In Baltimore and Washington, D.C., several alleys in the historic districts close to downtown have been rediscovered as quiet residential retreats, protected from the noise and bustle of the major streets.

In some cases, posh residential areas have replaced the most notorious alley courts. Alley gentrification follows a pattern initially developed in London, where mews houses (former carriage houses) in the alleys were restored and gentrified. While the townhouses fronting the streets have been carved into flats, the mews and alley houses serve as upscale cottages for the urban elite. This is a complete reversal of the picture painted in early twentieth-century exposés like Jacob Riis's *How the Other Half Lives*, which depicted alley housing as the worst of the

worst. Indeed, Grady Clay points out the irony that by 1970, two United States Senators and three members of the House of Representatives were residents of the same alleys that Riis had warned Congress about in 1904. While alleys remain ideal locations for utility poles, trash dumpsters, marginal belongings that are not quite ready for Goodwill, and a variety of junk, they can also offer quiet retreats and a cozy scale. American alleys vary tremendously in their usage and degree of upkeep.

Alley housing has a mixed past. Although most alley houses were originally modest cottages or makeshift quarters intended to house low-paid laborers or servants, they can also appeal to a wider variety of tenants. In periods of especially extreme housing shortages, such as during World War II, alleys were often used for accessory housing, usually built over garages. The clean and well-kept alleys of Coronado, California, home of a major naval facility, still have many accessory units dating from the war years. While they are no longer legal to build, the existing units continue to work well. Housing in Coronado is extremely expensive, but young teachers, house painters, and navy personnel can still live there affordably in these alley houses. This works out well for many of the elderly who live in the bigger houses fronting the street, as young tenants can do yard work and run errands in lieu of part of the rent. Conversely, elderly relatives can live in "granny flats" in the alleys instead of moving away to a retirement home. Alley housing enables a neighborhood to maintain diversity that would otherwise be lost in a hot housing market.

Alley housing was also a common feature in many rapidly industrializing cities during the early twentieth century, making it possible for extended families to stay together in tightly knit, working-class communities. In most cities, alley housing is no

longer permitted, although many neotraditionalists are beginning to question why. Indeed, with the condemnation of alleys by the Federal Housing Authority in 1938, most new developments no longer included alleys at all, lest they render the neighborhood ineligible for government-backed mortgages.

Advocates of a return to the traditional pattern of back-lot garages facing onto alleys argue that the arrangement does more than simply remove a dominating vehicular landscape from the front of the house. Back-lot garages can serve to enclose and define yard and patio space and give a sense of cozy privacy to rear play areas. The space between the house and garage can be an outdoor living room, especially when the garage is properly painted, ivy-covered, or aesthetically enhanced with trees or a trellis. Long, narrow lots with a garage on either side provide defined spaces and a set of sound and visual barriers. Parties on the opposite side are likely to be less irritating when distanced by two rows of garages and an alley compared to a chain-link fence between two back yards.

Alleys as Playgrounds

Children need messy places to play, and, despite their reputations, alleys can be just the thing. Everything from building forts to putting up basketball hoops is possible there. Of course, some of this play was once possible in front yards, but it is increasingly discouraged: codes and covenants often prohibit basketball backboards or only allow roll-out models between certain hours, usually during the weekend. Even without physical props, alleys can be good places for kids to hang out—free from too much parental supervision but still close at hand. This is the opposite of cul-de-sac play, in which every move is on display and can therefore needlessly aggravate

neighbors. Obviously, alleys work best when families and communities are tightly knit and children are more or less trusted. Perhaps therein lies the problem.

Alleys can be places for kids to experiment—plant a tree, paint a mural, build a tower out of furniture boxes, "steal" apples from a tree, learn to ride a bike. Most of these things are discouraged or not permitted in modern developments, and even learning to ride a tricycle can be dangerous when sidewalks intersect driveways every few feet. Adults need places to play as well—to repair motor bikes and chop firewood. The stuff of daily living does not always fit neatly into a pristine suburban landscape. Of course, if large numbers of cars use an alley, it can become too dangerous for casual play.

Why do alleys so often have a bad name? Alleys have always had their share of characters. When I was a child, there were "bag ladies" and "bums" in the alleys (no one used the word *homeless* then) and they were usually tolerated by the community. While they sometimes appeared to be disheveled, they did not threaten the status of the neighborhood by being visible on the street. They often lived in "rooms" above or behind shops, and most people in the neighborhood knew their names. One could argue that they had been semiacculturated into the community. Although occasionally criticized, this segment of the population was generally accepted and quite common. This is very rarely the case in modern suburban America. A ragged man or woman with a shopping cart walking down a residential street is widely regarded as major threat to community serenity and highly symbolic of neighborhood deterioration. Since the "homeless" are harassed or even arrested in many areas, they increasingly concentrate in certain vulnerable, less visible locations.

Today, street characters sometimes cluster in older neigh-

borhoods with alleys, especially in the alleys behind older commercial streets or streets with large, impersonal apartment buildings. If the number of marginal denizens reaches a level where a subculture develops (shades of Dickens), the environment can become threatening. Drug-dealing, car-stripping, fencing of stolen property, and prostitution sometimes occur in urban alleyways, confirming the belief that such places are necessarily conducive to evil. But this line of reasoning places the cart before the horse. Just as we once blamed the conditions of skid row on the people who lived there instead of looking at structural causes like the role of redlining by lending agencies, planned clearance, toxic dumping, slumlords, concentrated homeless shelters and other social services, and massive commercial overbuilding, we now sometimes blame alleys and their denizens for urban crime. We have come to understand how skid rows developed and how they can be fixed (often turning them into gentrified historic districts in the process), but we have yet to turn much serious attention to alleys.

Nevertheless, some experiments are occurring. By the early 1990s, some problem alleys, such as those in the Mission District of San Francisco, had been reclaimed by residents for murals and art projects and have since become symbols of community pride. Others have been modified to encourage pedestrians but exclude vehicular through traffic. Closing the alley at the middle of a block, for example, allows for rear access while eliminating speeding cars and some opportunistic crime.

There is a certain turnabout in the association of crime with alleys. Jane Jacobs, in *The Death and Life of Great American Cities*, wrote about the importance of "eyes on the street," a condition that exists when life is focused toward the fronts of houses and apartments. If houses are "gregarious," that is, they communicate with the street via big living room windows, front

porches, grand entryways, and the like, strangers feel that they are on a street that is part of a community—a sort of neighborhood living room. They are also likely to feel that they can be observed by residents who are watching the street as part of their normal, daily routine. However, reorienting houses toward a back patio and replacing the house facade with blank garage doors has changed all that. Even with all the mandated controls over color, vegetation, vehicles, trash, and other aesthetic concerns, the street is more likely than ever to be a no man's land. Where windows on the street exist, as when a second story has been added, they are likely to be in guest bedrooms at the less desirable front of the house. It is possible that many of these carefully controlled "safe" communities are more vulnerable to crime than they are advertised to be. Perhaps by putting garages in alleys, streets could be made friendlier and safer. We need to continuously monitor the successes and failures of the types of spaces we construct between our buildings.

Sidewalks and the City

Like alleys and driveways, sidewalks make up an important part of the "landscape of movement" surrounding our businesses and dwellings. Unlike the first two, however, sidewalks are for pedestrians, strollers, tricycles, and perhaps the occasional in-line skater. They were designed to separate and protect people from vehicles, not to throw them together. This makes it all the more ironic that, in recent years, so many sidewalks have become little more than a series of driveways. Sidewalks have a surprisingly short history since coming to the scene in eighteenth century London. While American cities soon followed the English pattern, it was not until the mid-nineteenth century that the streets of Paris and most other Eu-

ropean cities were lined with pedestrian walkways. Until then, pedestrians vied with horses, carts, and wagons for a space in the mud and filth of the street. It is little wonder that enclosed shopping arcades first gained popularity in Paris as people sought refuge from the street.

Providing sidewalks has always required making some tough decisions regarding the use of urban space. Especially in older European cities with established street patterns and existing buildings, sidewalks meant creating space for pedestrians just at the time that vehicular movement was increasing. Consequently, sidewalks tended to be very narrow where they existed at all. The contrast between these narrow sidewalks and the vast pedestrian spaces created on the new grand boulevards of cities like Paris and Vienna during the nineteenth century was astounding. The large crowds strolling aimlessly along Parisian boulevards depicted in the impressionist paintings of the late nineteenth century represented a new form of urban life. To be sure, promenades had existed before, along city walls or in gardens such as the Tuileries in Paris or Pall Mall in London, for example, but they were now integrated with ordinary business and shopping. To some degree, the promenade had become a normal, more democratic urban experience. Sidewalks caught on rapidly.

In many urban settings, however, the separation of pedestrians from vehicles presented an opportunity to extend commercial activities into sidewalk space. By the late nineteenth century, stores had begun setting up large signs and stacking overflow products, and cafes had claimed considerable space for tables. In addition, many businesses installed sidewalk elevators to make for convenient delivery to basement storage rooms, especially in areas with no alley access. Cellar doors to coal bins and stairways also intruded into the public domain.

The line between private businesses and the public street, always fuzzy, now had a new buffer zone to further complicate the matter. The issue has never really been resolved. In recent years, many cities have wrestled with the problem of how many sidewalk incursions to allow, but regulations often work at cross purposes. In California, for example, state law requires that alcohol be served only in enclosed, supervisable space. So sidewalk cafes there must have permanent or semipermanent walls or fences around them, preventing the temporary and casual arrangement of tables and chairs associated with Paris or much of Mediterranean Europe. The space, by law, must be officially claimed and delimited. Downtown San Diego currently has more than 100 fenced-off business areas on public sidewalks, most of which occupy about half of the width of the sidewalk, as regulations require an eight-foot setback from the street. The incursion of private business into public space raises some interesting questions. Should businesses have the right to refuse entry or even chase away "unacceptable" people from public space?

Sidewalk businesses have high visibility and can play a major role in defining the character of a district. Cities from New York to Pasadena are now debating what activities to allow (or encourage) in public space. Cafes and flower shops usually symbolize urban vitality, so they are encouraged to spill out onto the sidewalk so long as they conform to certain aesthetic standards; but what about used book stalls (à la Paris), displays of pots and brooms from hardware stores, vegetable markets, racks of discount clothing, kitchen appliances, or electronic equipment (with the associated music)? At what point does urban vitality begin to resemble a swap meet? How do issues of class and ethnicity affect decisions? The issue is especially important in neighborhoods like the Upper West Side in New

York City, where several businesses, mainly restaurants, have been allowed to extend essentially permanent additions onto the public sidewalk.

Sidewalks must also accommodate various public amenities and infrastructure elements—street trees, street signs, trash cans, utility and light poles, bus stops and shelters, benches, parking meters, gas meters, and parkways. In some commercial areas, sidewalks can seem quite crowded and cluttered, yet they can also be fun. In Portland, Oregon, for example, planters with statues of beavers and other Northwest animals adorn several downtown sidewalks along with signs pointing out the distances to Tokyo and Buenos Aires. Boston and several other cities in New England have adopted a "gritty cities" theme of bronze sculpture representing everything from typical workers from bygone days to discarded papers and fish bones from long-destroyed markets. In New York City, bronze citizens sit on park benches reading a book and enjoying the sun, as if to demonstrate the proper way to use urban space for a busy and preoccupied modern populace.

Advocates of good sidewalks are many. Jane Jacobs has argued that daily "sidewalk ballets" allowing brief encounters with semiacquaintances make for safer streets and varied urban life. The "eyes on the street" that are part of a rich sidewalk life allow children to be safely assimilated into the urban scene and make it possible for the elderly to maintain a variety of contacts that would be lost in suburbia. I found this to be true as a child, growing up on a traditional urban street with stores in one direction and a park in the other. We "knew" everyone for blocks around because we often met walking. Even today, in the busier 1990s, I have a number of casual acquaintances whom I have met strolling in my older neighborhood.

A brief caveat is in order. While sidewalks clearly symbolize

pedestrian space in the city, some might argue that they have been a mixed blessing in many contexts. For example, when no sidewalks exist, as is the case in many of the older sections of European cities, it is not clear who the streets belong to—cars or people. If the scale and street morphology are appropriate for pedestrian activity, walkers and drivers tend to accept the fact that each has a right to be there. When sidewalks are added, spaces become specialized. Streets become places exclusively for cars, and anyone crossing them must be on the lookout.

While some cities have created interesting pedestrian spaces along the street, many American sidewalks are empty almost to the point of total abandonment. Some suburban residential areas have been built without any sidewalks at all, as if no one in their right mind would venture there without a car. In some suburban commercial districts, partial sidewalks are commonplace, which connect two or three businesses but fade into weeds and truck-filled lots for a block or so only to return just before all hope for finding a place to walk is lost. In other new commercial areas, narrow sidewalks have been constructed adjacent to the curb, but without green parkways or strips of trees. When combined with a policy of prohibiting on-street parking, such walkways can seem harrowing as traffic whizzes by only inches from the few pedestrians who may have wandered onto the scene.

Where streets are wide and busy, the design of good sidewalk spaces can be a game of inches. When sidewalks are a comfortable width and have a double buffer of a parkway (preferably with trees) and parked cars to shelter pedestrians from passing traffic, strolls along even these active streets can seem pleasant. It also helps to have a continuous wall of buildings full of doors, windows, and gregarious facades so that attention is drawn inward, away from the street. When sidewalks

and the adjacent buildings are badly designed, it is difficult to get most people to walk more than about fifty feet. On the other hand, strolling along a pleasant sidewalk with a minimum of automobile entrances and plenty of friendly buildings and people is a large part of the nostalgic image that many urban and suburban residents have of the imagined joys of small town living. Of course, when streets are narrow and calm, both pedestrians and drivers can partake of a pleasing visual experience.

Second-Level Walkways and Underground Passages

When buildings were built close together as if they were one solid mass, it was easy to cut passageways between them. In traditional Islamic medinas, for example, rooms have been added by simply rearranging the position of interior walls. The labyrinth of cells that characterizes such places has always made them seem mysterious to Westerners. In the West, it is more common to think of buildings as separate entities and to maintain individual and distinctive front doors. Still, traditional European cities have their share of passageways as well. Florentine palaces were sometimes connected by upper-level corridors, and Venice has its famous Bridge of Sighs arching over a canal. In Chester, England, a system of covered, second-level walkways called "the Rows" appeared in medieval times as residents, perhaps hoping to avoid periodic flooding, built new structures on top of Roman ruins. By the time trains arrived from nearby Manchester and Liverpool during the nineteenth century, Chester was already gaining a reputation as a delightful place to stroll and shop. The nicer shops were on the second level, while mundane establishments lined the sometimes muddy streets. Arcaded sidewalks had long been common in Europe, but Chester's arcades were physically separate from the street. Social segregation along urban walkways had begun.

SPACES FOR DRIVING, STROLLING, AND PARKING

This nearly forgotten tradition of interior passageways, upper-level walkways, and architectural connecting devices was revived in North America only with the advent of modernism in the early years of the twentieth century. Inspired by Le Corbusier's plans for the radiant city as an efficient machine in which pedestrians would be totally separated from traffic-filled city streets, proponents of urban renewal began to develop schemes for putting cars and people on different levels.

The first projects were tentative. As office buildings and hotels became taller, skybridges were sometimes constructed in order to minimize the number of long elevator trips necessary to reach nearby additions. The Metropolitan Life Tower (1909) in New York City, for example, features a bridge constructed two decades after the original tower, leading to a large addition. In Columbus, Ohio, a replica of the Bridge of Sighs was constructed in 1927 to connect a skyscraping office tower to a luxury hotel and restaurants located across an alley. Still, these upper-level passageways remained quite rare as late as the 1950s. Until midcentury, most schemes involved the use of superblocks with interior walkways. One of the earliest and still most famous examples is Rockefeller Center in New York City. Completed during the mid-1930s, the complex includes a sunken plaza (which transforms in the winter to an ice rink), surface-level pedestrian corridors, and underground passageways. The Depression and World War II slowed emulation of the project, however, and most plans were put on hold until the boom years of the 1950s.

When construction picked up during the 1950s and 1960s, the concept of upper-level connectors and segregated pedestrian corridors became associated with futuristic visions of the modern, efficient city. During the mid-1960s, elevated walkways became integral parts of such massive urban renewal schemes as

THE SPACES BETWEEN BUILDINGS

the Charles Center project in Baltimore and the Golden Gateway Center in San Francisco. By the late 1960s, skybridges became popular in dozens of cities, connecting existing buildings as well as those in newly planned districts. Some of the earliest postwar bridges connected office buildings and department stores with the multilevel parking garages gaining popularity.

The first really extensive use of skybridges occurred in Minneapolis. Inspired by the images of modernism as much as by its exceptionally cold winters, the city began planning second-level connectors as early as 1959. Zoning bonuses were awarded to developers who included connectors in their projects, and by the 1980s a vast indoor city had evolved linking parking garages, department stores, office buildings, and entertainment facilities. The opening of the grand atrium in the IDS Center office building in 1972 added a centrally located indoor gathering place, as well a certain panache, to the system. The internal corridors are popular: on cold winter days, the city's streets are deserted.

Several other North American cities have followed suit. Calgary now has one of the most extensive system of upper-level enclosed walkways (referred to as "plus-15s," because they must be at least fifteen feet high). They are required in all central downtown developments and are open twenty-four hours a day. While Canadian cities tend to have more attractive public spaces than those in the United States, where skybridges prevail, city streets are no less deserted. Still, they are an obvious amenity that largely eliminates the need to deal with heavy coats, galoshes, and gloves during lunch breaks or quick shopping trips before the long commute home.

Weather, however, does not seem to be the determining factor behind enclosed walkways. A number of cities that have milder winters (but hotter summers), such as Cincinnati,

Spokane, Atlanta, and Charlotte, have adopted the skybridge as symbolic of big-city sophistication and good planning. In cities like Miami and Detroit, they have been combined with elevated, "people-mover" transit systems that are also segregated from the street. The jury is still out on the impact of these bridges.

On the positive side, systems of internal corridors and skybridges can encourage the development of compact downtown areas with easy pedestrian access to a variety of amenities. This is important in a society in which not many people will walk more than a few hundred feet and many feel that, under normal circumstances, a car is necessary for even the shortest trips. Skybridges and corridors also provide access to at least parts of buildings that would otherwise be locked up, allowing people to cut through them to get to a shop or cafe. This also encourages the construction of semipublic amenities like garden-filled atria, where people are encouraged to sip coffee and read the daily news en route to work or play. Increasingly, museums, libraries, and other civic establishments have been combined with the usual shopping and eating spaces in these corridors. The bridges and corridors also allow massive parking facilities to be shared by a wide variety of establishments rather than breaking up the urban pattern with smaller, scattered lots. Such passageways remain warm in winter and cool in summer and, normally, are devoid of bugs, exhaust fumes, and slush.

There are, however, some real concerns about the effects of walkways. Conceived originally as a way to facilitate interaction between buildings and to relieve the assumed congestion of city streets, skybridges are ironically used very little in the few North American cities where congestion does at least occasionally exist, such as New York, Chicago, and San Francisco. Rather, they have become popular in cities where there are few,

if any, pedestrians on most downtown streets. The result is the "city as fortress" syndrome—a mass of interconnected, towering structures with little or no visible life on the street. To the extent that private building interiors serve as public space, real public exterior space becomes impoverished and ignored. Behavior is carefully monitored in the atria and walkways, and people who are deemed unacceptable are often barred. Political activities and, indeed, any activities that might seem objectionable in an environment primarily geared for consumption are typically prohibited, although some recent court decisions have ruled to the contrary. Meanwhile, a vicious circle develops. As the streets and civic plazas become more deserted (and so, dangerous), people flock to the protective cocoon of inside walkways for safety and protection from undesirables, who are kept out. Furthermore, as there are few doors to the megastructures, the streetwalls are increasingly blank and boring. There is no reason to decorate streets where no one (of any importance) walks.

The skybridges are also usually aesthetically marginal. While some are well-designed and decorated, close up, most appear plain, functional, and boring. More importantly, views of the city are disrupted. Once-grand vistas of civic buildings, office towers, rivers, and parks are now often blocked by overhead walkways. Although not as ugly or chaotic, the effect recalls the maze of overhead wiring that engulfed North American downtown areas at the turn of the century.

Underground Passages

It is likely that underground tunnels have been around as long as cities themselves. After all, there had to be a way for discredited leaders to slip off to safety beyond the city wall. The use of underground space for movement, however, took on

new importance during the nineteenth century with the advent of the subway. There had been tunnels for trains much earlier, of course, especially in mines and through mountains, but by the mid-nineteenth century people began to think of underground railroads as an appropriate device for intraurban transportation. Although New York City had experimented unsuccessfully with the idea as early as 1849, the opening of the London Underground, in 1863, marked the beginning of a new era in movement as well as the use of a new level of space between buildings.

The London Underground was conceived as a way to link the several independent railway stations that ringed the city and thereby facilitate cross-country (and cross-city) rail traffic. Engineers initially used a "cut and cover" method that involved simply digging a ditch and putting the tracks below street level. Because the trains burned coal, the problems of dirt and ventilation were immense. (It is no wonder that everyone wore black in Victorian England.) Most people assumed that as cities became more congested, overhead rail systems would be constructed at various levels. During the early twentieth century, several publications pictured the city of the future as having many layers of transportation piled one above the other. A few cities, among them New York, Chicago, and Boston, did build elevated railroads, but they were not always popular. Their noise and smoke made host streets unpleasant. Many lines were torn down when subways became an option, although Chicago's "El" remains a powerful symbol of the era. Many suburban lines in North American cities also remain above street-level, and a few new (and controversial) people-mover systems have appeared. It is difficult to make an elevated railway or a monorail attractive, and, of course, views of city architecture are interrupted.

By the end of the century, the advent of electrical power trains and new tunneling technologies greatly improved underground railways, and they began to enjoy wide popularity. Boston built the first system in North America, beginning in 1897, and New York City completed its first line in 1904 and continued expanding it through the 1930s. Almost as soon as the subway had been invented, some urbanists began to envision the expansion of an extensive underground city. In London, for example, a plan was put forward as early as 1860 for passageways with shopping, offices, and even housing, all linked to a below-ground transportation system and illuminated by an overhead glass arcade. Little was actually done, however, as just getting subways themselves built was enough for most cities to handle.

Underground passageways are so expensive to build that they usually make sense only when combined with the construction of subway systems. As a result, pedestrian tunnels have not become as trendy and widespread as skybridges. Montreal has the most extensive system in North America, but less ambitious projects can be found from Toronto to San Francisco. In San Francisco, for example, zoning bonuses were awarded to office tower developers for constructing access tunnels connecting to the Bay Area Rapid Transit system. The idea was to get people into and out of downtown without their ever having to walk on a street. Partly as a result, Market Street has lost at least a little of its character. A few modern, high-density, mixed-use megaprojects such as Crystal City, near Washington, D.C., also feature extensive underground shopping passageways, but they tend to underscore the bleakness of the surrounding surface streets.

There are cities in the world where underground tunnels do work very well for a variety of purposes. In Tokyo and other

major Japanese cities, the streets are narrow and very crowded. Having shopping malls and recreation facilities tied to subway and railroad stations makes a lot of sense. Traffic might simply grind to a halt otherwise. In most North American cities, however, there are already far too few people on city streets, so the motivation for building sidewalk alternatives is suspect. The goal may be to keep people inside in a world designed for consumption.

The Design and Character of City Streets

Much of the literature describing the morphology of cities focuses on the spatial organization of their street systems. The early grid plan of Miletus and its subsequent adoption by Roman cities, the radial pattern of Versailles and Karlsruhe, the ring roads of Paris and Vienna, the irregular maze of the medieval or Islamic city, and the mismatched grids and curvilinear streets of the modern North American city are all starting points for understanding how urban places are put together and how they function. In medieval cities streets were little more than a labyrinth of narrow paths for pedestrians and perhaps small pack animals. They were built as integral parts of local neighborhoods and communities rather than as routes for through transit. They evolved through use rather than being designed from above or afar. People often followed a natural path of least resistance. Although it has often been said that Boston's irregular street pattern was laid out by cows wandering down to the river from their pasturage on Boston Common, such casual and gradual street platting has been rare in cities over the past two centuries.

By the early nineteenth century, most American cities were organized around a regular grid system with straight streets

and rectangular blocks. Several cities, such as Philadelphia and Savannah, had been carefully planned this way at much earlier dates, but grid planning was unusual before 1800. It was not so much enthusiasm for good planning as the need to make speculation convenient that increased the popularity of the rectangular grid. As the pace of urban development quickened along the urban frontier, rectangular blocks provided building lots with predictable, recognizable dimensions. Potential buyers knew exactly what a 50 by 100 foot lot was and what could be done with it. All that was needed were the block and lot numbers to identify the real estate product. As the popularity of the speculators' grid increased, often the ornamental squares and diagonals that had constituted important parts of the design of Philadelphia, Savannah, and New Orleans were dropped in favor of a simple, unadorned system of straight streets and rectangular blocks. With the passage of the 1811 plan that mandated a grid for nearly all of Manhattan, a new standard for the North American city was established. The grid would continue to reign supreme for over a century.

Still, there were decisions to be made concerning the length and width of blocks and the size of streets and sidewalks. Street widths have varied tremendously over the centuries. Traditional Islamic law mandated streets wide enough for two loaded camels to pass, but in many medieval cities it was difficult to enforce such rules and buildings soon inched outward into the public domain. I have encountered numerous streets in Spanish cities like Cordoba too narrow for one Volkswagen to pass through. Medieval patterns were still common when the earliest North American cities were settled during the seventeenth century; some of the older lanes in Boston and lower Manhattan, for example, are barely twelve feet wide. Such

streets often extend the commercial and residential areas around them rather than provide through traffic routes.

As the grid prevailed, streets generally became wider, but not by much. Most of the east-west streets in Manhattan are narrow, as are many of the older streets in cities from Cincinnati to San Francisco. Throughout the twentieth century, new streets became successively wider, while many older ones were broadened. It is not uncommon in some newer areas to have streets with eight or ten lanes of traffic. For a pedestrian, crossing the street is a significantly longer walk than the length of an average city block in a traditional downtown, coupled with the tension one feels when the "walk" light turns red two steps into the journey. These trends are the result of transforming our cities from spaces between buildings to buildings set in space.

Urban planners have long worried about street width. Seventeenth-century city planners in Paris and Amsterdam wrestled with the ideal relationship between building height and street width. Although usually couched in health issues such as ensuring adequate light and air at street level, aesthetics mattered in determining the ideal. Where streets are tiny and buildings massive, as in the older parts of Genoa, Italy, or parts of Lower Manhattan, a feeling of dank claustrophobia can prevail. At the opposite extreme, a kind of agoraphobia appears when streets are wide and buildings are low. Pedestrians are literally lost in space, surrounded by speeding vehicles. Most people prefer places somewhere in between. There are many variables to be considered. In American cities, the ideal street normally contains both cars and people. Midsized streets with curbside parking and adequate sidewalks coupled with stop signs and other traffic-calming devices are adequate both for travelers and as important community space.

Urban Morphology and the Character of Cities

The size and shape of city blocks is important in determining the character of an urban area or neighborhood. Even where grids prevail, variations in the size of blocks and streets make for very different urban personalities. In Manhattan, the blocks have long east-west dimensions, with their narrow ends fronting the north-south avenues. Consequently, it is more fun to walk on these north-south avenues if one enjoys more cross-streets, corners, options for turning, and a feeling of making progress as the blocks pass by. In contrast, many of the east-west streets are too long and uniform, which can be monotonous. The prestigious locations are on the avenues. The Upper East Side, however, is characterized by shorter distances between north-south avenues and thus smaller blocks, creating a zone of higher desirability for commerce and residences, as a walk around the block is easy and pleasant. Similarly, where Broadway angles through the long blocks of the West Side and bisects them, as at Times Square and Columbus Circle, the resulting spaces have become highly visible and desirable nodes of activity.

Analyses of morphological variations among modern North American cities have been largely ignored. Urban scholars have done a much better job of cataloging the differences in street patterns between cities in very different cultural settings, such as between Vienna and Beijing. A recent book by Allan Jacobs entitled *Great Streets* features same-scale maps of the street patterns of various world cities from Cairo to Brasília. It drives home the point that urban character is sometimes set even before any buildings are added to the scene.

Too often, urban scholars have assumed that American grids are basically all alike, or at least similar enough to merit little at-

tention. Although the differences are subtle, variations in the grid influence the character of North American cities. Even relatively new cities like Sacramento and Salt Lake City are very different, at least in their downtown areas. The former has narrow streets and small blocks, while the latter has huge blocks and very wide streets. Sacramento has sought to invigorate its downtown by developing tree-shaded pedestrian streets, outdoor cafes, light-rail transit, and historic preservation districts. These are not really options in Salt Lake City, as the scale is completely different. Downtown is characterized by easy traffic flow and ample parking, grand vistas, suburban-scale buildings, and a general sense of openness.

Which is better, small streets and short blocks or wide streets and big blocks? Planners and designers keep changing their minds. During the 1950s and 1960s, most planners advocated the elimination of numerous streets through the creation of superblocks. Streets, after all, were wasteful and only encouraged the unhealthy mixing of cars and people. Beginning with Rockefeller Center in the 1930s and gaining strength after World War II, superblocks were used in the development of everything from public housing to civic centers. Systems of small streets were replaced by superblocks surrounded by wider and busier thoroughfares. In downtown San Diego, for example, a superblock civic center built in the 1960s created a wall through the middle of the central business district that has acted as a barrier to development for nearly thirty years.

In contrast to those who argue for superblocks, there are many who feel that short blocks with numerous cross-streets are best-suited for urban life. They insist that big blocks surrounded by major thoroughfares isolate activities and diminish urban life. Not long after the huge blocks of Salt Lake City developed in the late nineteenth century, for example, city leaders

THE SPACES BETWEEN BUILDINGS

decided that the blocks were far too large and that smaller streets and alleys should be cut into them at various places. This view has now become an important component of the neotraditional urbanism movement, which advocates, among other things, a return to narrow streets, small blocks, and alleys. Neotraditionalists point to downtown Portland, Oregon, as a prime example of what a good city should be, in part because of its simple grid, small blocks, and narrow, tree-shaded streets. Obviously, street morphology is not the whole story, but downtown Portland is a very attractive place for walking, even in the ever-present rain.

Even when grid plans prevail, there are sometimes complications, as when multiple grids exist in the same neighborhood. In North America, where competitive speculation has often been more important than good planning, it is common to have one system of streets oriented to the waterfront, while an adjacent system is parallel to a road or railway. In cities as diverse as Atlanta, Denver, San Francisco, and Seattle, mismatched grids have played important roles in the spatial organization of central districts. When different grids meet, the result is often a series of awkward spaces in which movement is difficult. Such spaces can be barriers for pedestrian and vehicular movement, discouraging the expansion of various commercial or social activities. They become breaks in the urban fabric. In New York City, for example, Greenwich Village has remained somewhat protected from the bustle of Lower Manhattan, partly due to its mismatched grid.

Central San Francisco has long combined two very different grid systems. North of Market Street, where the action has traditionally been, the streets are narrow and the blocks are small. Locals and tourists alike enjoy strolling on the streets of downtown San Francisco, Chinatown, and North Beach. Market

Street runs at an angle to this grid, and the streets to its south run parallel to it. South of Market Street, the streets are wide and the blocks are long. For nearly a century, Market Street has acted as a barrier against southward downtown expansion. Most of the northern streets dead-end into Market, and the street itself is lined with major office, hotel, and retail buildings. Most pedestrians find that getting past this awkward, if subtle, barrier presents just enough of a problem to dissuade them from going further. The city has tried to revitalize the southern part of downtown with urban renewal schemes, zoning bonuses, a new art museum and convention center, and housing programs. Still, the nature of the street system works against the total success of such plans.

Great Streets

Even those who advocate small streets and short blocks admit there is also a place for at least a few monumental streets. In the past, unusually wide streets often symbolized importance. Grand boulevards, such as the Champs Élysées in Paris, Commonwealth Avenue in Boston, Monument Avenue in Richmond, Virginia, and Market Street in San Francisco, are places where things are supposed to happen. The origin of the grand boulevard idea in Paris may have been to facilitate control so troops and cannons could be more easily rushed in. More recently, grand streets have provided prestigious business or residential addresses such as Park Avenue (New York City), Peachtree Street (Atlanta), or Wilshire Boulevard (Los Angeles). Increasingly, however, major streets may be losing symbolic importance, as they are designed to be arterials rather than grand boulevards.

It has been a long time since a great street has been designed in an American city. Indeed, we may have lost our ability or at

least our will to do so. A grand boulevard is a place for activity as well as movement. It is a street where pedestrians, cafes, automobiles and buses, beautiful architecture, and luxuriant vegetation can all coexist. It combines prestige and high rents with the efficient movement of people and goods, often below ground as well as above. It is the perfect hybrid—a beautiful urban setting and an efficient piece of transportation infrastructure. As such, it may be out of fashion in the increasingly specialized North American urban scene. We have turned our attention to pure types of streets, ranging from quiet residential cul-de-sacs to multilane freeways. The middle ground has suffered as a result. We have big streets but not great streets. We have six-lane highways lined with malls and discount stores, but the destinations have little relationship to the street. Typically, the only connections between the buildings and the highway are the gaping entries to vast parking lots. Once inside, the street is forgotten and irrelevant.

On a grand boulevard, the street is everything. The buildings, the people, the signs, the trees, the lights, and the passing traffic are all part of the festive scene. Beyond this description, it is difficult to provide specific details for the definition of a grand boulevard. They come in all sizes and shapes, from the nearly normal dimensions of Fifth Avenue in New York City or Michigan Avenue in Chicago to the immensely wide Avenida 9 de Julio in Buenos Aires, but it is the life and image of the street that is important, not its sheer size. It must carry traffic, however, so streets that are pedestrian-only or nearly so do not qualify even if they are lively and prestigious. On the other hand, even the "Main Streets" of small-town America, once popular for cruising and strolling, were grand boulevards on a smaller scale. Not all grand boulevards need to look just like the Champs Élysées.

SPACES FOR DRIVING, STROLLING, AND PARKING

Do we miss great streets or grand boulevards? It is hard to say. While people are flocking to a number of revitalized great streets, from Robson Street in Vancouver to Newbury Street in Boston, there are no new grand boulevards in the making. Broadway in New York City or Wilshire Boulevard in Los Angeles may still fit the description of great streets, but the new suburban highways in the booming edge cities, like Tyson's Corner near Washington, D.C., or Irvine, California, are very different. It seems ironic that in this age of near total dependence on the automobile, we have lost our ability to create grand boulevards. In losing this type of great street, we have lost what is, in most communities, the place where civic identity is strongest. No wonder, then, that we complain about the privatization of public space as malls have become substitutes for streets. Much of this has to do with the way we organize our newer streets and neighborhoods.

While many other cities of the world have built intercity freeways and even outerbelts, U.S. cities have gone further, carving up city centers with massive freeways and interchanges. Instead of using grand boulevards to bring traffic into the city from a freeway, we have built innerbelts connected by numerous spokes to outerbelts. As a result, American cities are segmented and segregated by walls of traffic. While great streets can give a section of a city unity and coherence, freeways create unpleasant barriers. Most American downtowns, for example, are physically and psychologically distant from surrounding neighborhoods because of central freeways and interchanges. Recognizing this problem, a few cities have sought solutions. Seattle built a freeway park on top of a busy Interstate, while Boston is burying a downtown highway. San Francisco removed a downtown freeway badly damaged in an earthquake. These are expensive solutions, however, and most

cities will likely continue to live with freeway barriers. Indeed, freeway dependence may be increasing not only because of the growing reliance on cars but also because of the trend toward eliminating networks of small streets in favor of a combination of freeways, megastrips, and pods of activity.

Gridding versus Podding

After a century or so of relentless grid platting, many of the designers and developers of North American cities began in the 1890s to search for alternatives, especially for suburban residential areas. Congestion and traffic were overriding concerns for elite areas, which sought a degree of isolation from the bustling city. By the early decades of the twentieth century, a curvilinear street pattern (perhaps derived from cemetery layouts) had emerged as the leading option. Most of the curvilinear patterns developed from the late nineteenth century on through the 1920s and 1930s, however, were essentially picturesque variations of the grid, sometimes referred to as a "warped grid." It was still possible to walk (or drive) around the block, even though the experience might involve a bit more confusion. The curves served to enclose views and add visual interest to the newly developing neighborhoods. The combination of narrow, curving streets with curbside parking meant that through traffic tended to move slowly. From Shaker Heights, Ohio, to Beverly Hills, California, some of these neighborhoods remain among the most desirable in North America.

Other ideas for enhancing the layout of cities competed with the curvilinear streets and warped grids. Influenced by the English Garden City Movement, the new profession of city planning argued for alternatives to the grid during the early 1920s. When the Radburn project in Fairlawn, New Jersey, was completed in 1928, a new model of the ideal suburban neighbor-

hood took hold. Radburn features the "neighborhood unit" and a "hierarchical road pattern," in which the two-square-mile development is surrounded by major arterials with 120-foot right-of-ways, while inside the community there is a hierarchy of poorly-connected streets, the smallest ones toward the center. The hierarchical design protects the neighborhood from through traffic. Advocates of the Radburn Plan also argued that since the total amount of surface given over to streets is less than in a grid system, the extra space can be used for parks. More often, however, the result has simply been more houses built on fewer streets. The Depression slowed the diffusion of the new ideal, but by the late 1930s support for it had increased. When the Federal Housing Authority rejected the grid in favor of the new protected cul-de-sac pattern in a 1936 publication, it set the stage for a different type of urban area to emerge. Since the FHA provides development standards and appraisal guidelines in association with government insured mortgages, it was in a powerful position to shape future growth and encourage lenders to discriminate against older urban neighborhoods where grids and alleys were common.

Things really began to change after World War II. As automobile and truck usage increased, the threat of through traffic in neighborhoods loomed large as a potential destroyer of domestic serenity. Cul-de-sacs, therefore, became popular for residential areas, and superblocks with huge parking lots became the norm in commercial areas. The idea aims to create isolated "communities" or "villages" by channeling through traffic onto major thoroughfares sweeping around the protected communities. Only a limited number of access roads allow entry into each community, so the blocks, if they can be called that, are very long. These large areas, encompassing shopping malls, vast discount centers, medical complexes, and dead-end resi-

dential streets, have been termed *pods*. They are designed to handle local, place-specific visitors, while all through traffic whizzes by on major multilane thoroughfares.

These major thoroughfares are wide and busy, but they can rarely be called great streets. There are no median strips filled with fountains, statues, and greenery, such as might be found on the Paseo de la Reforma in Mexico City. They are rarely lined with great architecture either. In commercial areas, major highways typically are fronted by massive parking lots and huge signs, while in residential areas concrete walls are increasingly used to shield houses from traffic noise. Joel Garreau, in *Edge City*, suggests that Americans do not like to walk more than 600 feet unless they are in pleasant surroundings. By the time a pedestrian leaves a store, crosses a parking lot, crosses a major boulevard at the nearest traffic light, and crosses another parking lot to a "neighboring" store, this distance may be greatly exceeded. It is no wonder that traffic clogs suburban commercial areas, since people often drive to go next door.

There are other problems as well. Modern residential areas are designed in a dendritic street pattern with small, dead-end lanes branching off from main entry roads. There is only one way out of such cul-de-sacs; "downstream," to ever-larger and busier streets until finally reaching a freeway or major commercial strip. A variation on this pattern is the "loops and lollipops" system, in which circular street systems with many cul-de-sacs loop off a major highway. In both scenarios, the design goal is isolation and protection of residents from traffic. While this is sometimes accomplished, especially for the people furthest "upstream," most residents on a well-traveled access loop experience more traffic than they would in a traditional grid pattern, since everyone has no choice but to take the same path out of the neighborhood. Moreover, automobile use increases

SPACES FOR DRIVING, STROLLING, AND PARKING

as everyone in the family acquires a car, making what were planned as quiet suburban streets busy. The noise and commotion may be heightened on residential streets because of arbitrary standards for width and paving. Street width is often mandated by rules designed to allow certain types of fire equipment to maneuver, so residential areas may ultimately be designed by the builders of fire engines. Of course, cul-de-sacs can be awkward spaces for fire engines as well, and some cities have begun to discourage them in order to improve fire and police protection.

Residential isolation can be a mixed blessing. In achieving isolation from traffic, many have also achieved isolation from nearly everything else. Visiting friends, shopping, and other activities in locations only a few hundred feet away as the crow flies may require a mile drive down exit roads and then back up again in a dendritic street system. Children and the elderly may suffer especially limited mobility in a loop system, in which going anywhere out of the immediate neighborhood means going out to a big highway. Even if corner stores, recreation centers, and services are permitted by zoning in such neighborhoods, they probably cannot be supported since few pedestrians can get there (thus the need for large and controversial parking lots). In a grid system, a large number of streets and houses can be sited within a quarter mile—or a ten-minute walk—of a corner store. In a dendritic or loop pattern, only a very small threshold population has access from nearby, so everyone drives to the store and the streets get busier downstream. This street pattern augments the trend toward the dominance of superstores at the expense of slightly more expensive but more convenient smaller outlets. If nothing can be located conveniently, then you might as well drive to the Wal-Mart on the major highway.

An extreme desire for isolation can lead to the proliferation of gated communities and private streets. Private streets are nothing new. Several American cities, most notably St. Louis, experimented with the idea as early as the turn of the twentieth century. Historically, however, such streets were few and far between, and they were built adjacent to the prevailing grid. They are elite islands in a sea of more modest neighborhoods. Today there are far more gated communities, especially in California and other parts of the booming Sun Belt, and these are more likely to be poorly integrated into the community in other ways. At worst, only the busy, major highways are public, with gated loops and cul-de-sacs on either side. There is virtually no public space for the pedestrian and precious little for the driver. What are we so afraid of? Perhaps when the only perceived options are a residence in a gated cul-de-sac or one on a busy but uninteresting through street, people feel that they have a limited choice. Many surveys show that the most popular ideal setting for life in America is the small town or city with a traditional Main Street, houses, sidewalks, and (probably) a grid pattern. With very few exceptions, we no longer build such places. In the eyes of many developers, city planners, lenders, and home-seekers, traditional grids and narrow streets have a bad reputation.

Grid systems with small blocks and narrow streets are not perfect. In many older neighborhoods with high-density apartments, commercial and industrial uses, and a heavy reliance on public transportation, straight streets with through traffic can mean noise, pollution, and traffic hazards. When conditions get bad enough, everything from irresponsible speeders to alley drug dealers can make life on the grid unpleasant and dangerous. In some neighborhoods, selected streets and alleys have been closed off at the middle of the block in order to create

SPACES FOR DRIVING, STROLLING, AND PARKING

make-shift cul-de-sacs and give residents a greater sense of control over their space. In other cities like Vancouver, British Columbia, certain streets have been turned into pedestrian pathways so that people can still walk around the block and support local stores and cafes. In addition, some new cul-de-sac developments are linked by pedestrian paths. It can be argued that a traditional grid with small blocks and narrow streets tends to exaggerate local conditions: In good neighborhoods, where people feel safe and are enthusiastic about supporting local commercial and recreational facilities, the grid enhances the situation by facilitating interconnections. In bad areas, too many connections can be a bad thing; when problems arise, there is no place to hide. Perhaps an increasingly negative view of our society and our neighbors serves to reshape our cities even more than we realize.

Can Spaces for Movement Be Beautiful?

Early cities had few spaces designed primarily for movement. Even the grand parade routes in ancient cities were designed more for spectacle than travel. In most urban contexts, streets were little more than narrow pathways that served as extensions of the buildings around them as much as for movement. Over the past several centuries, people have attempted to add more and more movement while protecting perhaps romanticized notions of the early community street. The job was fairly easy until the nineteenth century, when the pace of intraurban travel picked up. For the most part, however, urban morphology remained pretty traditional until the early decades of the twentieth century. Since at least the 1920s, we have been developing new and often conflicting policies for trying to move people, cars, buses, and trucks through urban spaces. Every couple of decades planners arrive at ideologies and role

models that seem to assure us that we have finally found the solution, only to wake up and find the resulting disappointments, if not disasters, a few years later. We need to monitor the staying power of various types of urban morphology.

Eliminating alleys and adding small, one-car garages to house facades seemed like a good idea in the 1930s, but continuous rows of three-car garages on narrow lots make modern neighborhoods bleak and impersonal. Similarly, routing through traffic around communities seemed a fine plan in the 1920s, but the results today are often ten-lane highways with awkward traffic patterns, ten-minute waits for left turns, and virtually no pedestrian access or visual interest. Government programs and policies have often institutionalized our ideas before we have had time to understand the long-term results. As our commercial zones have become more hectic and blighted, our residential areas have become increasingly designed for refuge and isolation. Movement has become something to hide from, yet we must all move more than ever.

|| Shapers of Access

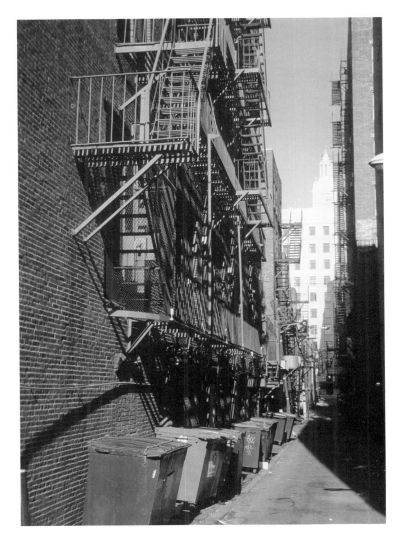

A tight, vertical alley provides the necessary functional space for fire escapes and dumpsters in Boston. As alleys have ceased to be built in modern developments, many of these functional features have had to be dressed up and put out front.

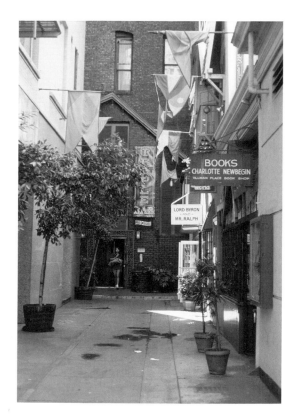

Often alleys possess a human scale that is a perfect setting for shops and cafes, such as these in downtown San Francisco. Once they are cleaned up, alleys can provide a cozy retreat from traffic-filled streets.

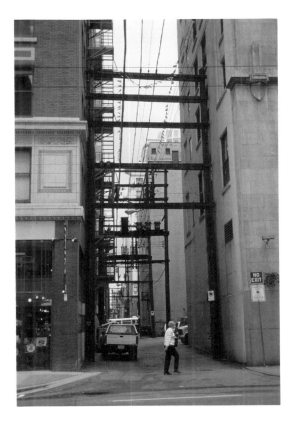

This alley is a place to hide overhead power lines in Vancouver, thus reinforcing the contrast between the aesthetic fronts and functional backs of buildings.

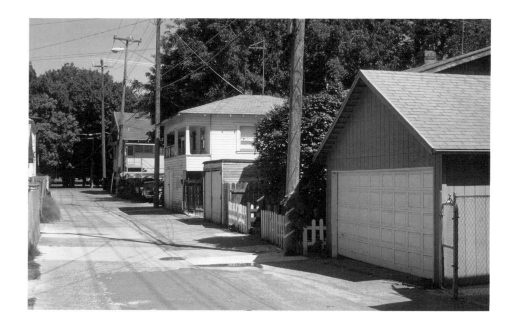

With the advent of automobiles, garages and secondary housing become the dominant features in paved alleys in Sacramento, California, and elsewhere. Such settings often provide ideal venues for play and work that is deemed by neighbors to be too messy to be out front.

Top: A front-facing garage and a side driveway define suburban houses in Falmouth, Massachusetts. Although they were more carefully designed than their "kit-from-Sears" ancestors, early side garages were still built well back from the house. *Bottom:* A revival of traditional alleys and rear garages is a feature of the New Urbanism community of Kentlands, Maryland, but strict codes disallow most traditional alley uses, such as storage bins and auto repair.

Top: When doors are left open, garage-dominant houses can look like airplane hangers or caves, as here in Sacramento. Many new residential areas have requirements that such doors be open for no more than a few minutes at a time. *Bottom:* Garages dominate houses in the alleyless landscape of Irvine, California. Multicar garages occupy much of the ground-floor space in these cul-de-sac neighborhoods.

A continuous street-level garage entry makes for an uninviting sidewalk for pedestrians in San Diego. As the number of front garage entries increases, sidewalks become little more than a series of driveways.

A walled housing tract and an empty sidewalk keep suburban priorities clearly defined in Irvine. Such neighborhoods are the polar opposite of "gregarious" residential streets, where friendly house facades and front yards create a stimulating semipublic domain.

A lone pedestrian catches a traffic break in an auto-oriented section
of downtown Baltimore, Maryland, where pedestrian walkways
occur at many levels. Successful urban design that separates cars
and people has not been easy to achieve.

The "El" uses the spaces over streets in downtown Chicago.
Dense urban centers often rely on several layers of transportation,
including underground and overhead lines.

The relationship between buildings and the street can be interrupted when vacant lots are dominated by parking and large signs, as here in Raleigh, North Carolina.

The street becomes a marketplace in the Italian North End of Boston. The age-old battle over whether the street is for people or traffic goes on as we continue to experiment with pedestrian malls and periodic street festivals.

The sidewalk is used for overflowing business in lower Manhattan.
Sidewalk displays have been around for a long time, but new
issues arise when they become essentially permanent uses of
public space.

In Athens, Georgia, a sidewalk cafe is the perfect intermediary
between buildings and street, especially when combined with
enclosing vegetation. Traffic can add life to a street as long as it
does not overwhelm other activities.

Buildings fade into the background when vehicular traffic requires
that streets widen, as here in Costa Mesa, California. This is espe-
cially true when buildings are low and set back from the highway.
Space dominates architecture.

CONCLUSION || **City Spaces and Human Nature**

SOME PEOPLE SEE THE GLASS AS HALF EMPTY, WHILE OTHERS see it half full. So goes the old description of the difference between pessimists and optimists. Perhaps this contrast is illustrated by many of the urban design issues discussed in the three essays of this book. For the past several decades, a basic disagreement has run through most of the literature on how buildings and the spaces between them should be designed. On the one hand, the prourbanists take a very positive view of people and society. Writers like Jane Jacobs and William H. Whyte argued as early as the 1960s that people enjoy good spaces and will generally behave nicely whenever such surroundings are provided. Good streets, sidewalks, parks, and other public spaces bring out the best in human nature and provide the settings for a civil and courteous society. Everything will be fine if we can just get the design right.

A number of writers have joined the early pioneers over the past few years, and today much of this somewhat nostalgic, optimistic literature can be loosely grouped under the banner of those advocating a return to traditional urban forms. The neotraditional or, ironically, "new" urbanism movement sees

happy people sitting on front porches and enjoying one another's company at corner stores.

While not in total disagreement with the goal of good design, many planners, developers, and lenders have a much more pessimistic view of modern urban society. They see a society filled with individuals just waiting to misbehave at the first opportunity. The job of good urban design should be to minimize contact and so minimize conflict. People need to be protected from one another so that our modern, busy communities can function smoothly with a minimum of distractions. This pessimistic view has been deeply rooted in American society, at least since the Victorian era of the late nineteenth century.

The Victorians, and the twentieth-century reformers who followed them, believed that the emerging middle class was a fragile thing, requiring constant vigilance to keep it from slipping back into the evil chaos associated with the unwashed masses. Since most, if not all, people were inherently sinful, society could only exist by following strict rules of decorum and protocol. These rules, beginning with good breeding, good manners, and proper dress, eventually wove their way into architecture and urban design.

Victorian domestic architecture emphasized the relationship between proper spaces and proper behavior. Parlors, music rooms, dining rooms, and children's play areas were included in the Victorian house to encourage desired middle-class activities and etiquette. French apartments, on the other hand, were criticized as amoral, if not immoral, because they lacked hallways and usually had bedrooms on the same floor as the more public rooms. People could be too easily tempted. Stairways should be used to separate activities and preserve privacy.

The Anglo-American residential suburb also evolved to sep-

arate people from one another and from the all-too-common temptations of urban life. Women and children could be sheltered from the coarse realities of commercial and industrial enterprises and instead pursue the more uplifting activities associated with life in the home. In Protestant and Puritanical North America, architecture and urban design have been called upon for at least one hundred years to lead us not into temptation. Consequently, the liveliest and most successful urban neighborhoods in America were often those of Russian, Italian, or Greek immigrants, who shared more optimistic views of the results of human contact.

Institutionalizing the Pessimistic View

As governmental and other institutional frameworks became more important during the first half of the twentieth century, the pessimistic view of human nature most often won approval. That is not to say that planners, lenders, social reformers, landscape architects, and architects were not optimistic that their considerable efforts to build a better urban landscape would improve society. In fact, clearing slums and building better housing convinced many progressives that social problems could be made to disappear. Still, while their view of the future might be optimistic, their designs often displayed a certain pessimism about human nature.

There is an easy explanation for the pessimistic view. Many of the traditional urban landscapes of North America had been worn out by overuse and overtaken by rapid technological obsolescence by the early years of the twentieth century. The combination of rapid population growth, massive foreign immigration, industrialization, and new technologies like central heating, indoor plumbing, electricity, and new building styles and materials caused many of the neighborhoods built before

the turn of the century to appear antiquated and obsolete by the 1930s. There was a general feeling that we could do better. During the interwar years, many of the values and attitudes that shape our cities were institutionalized.

The profession of city planning emerged out of landscape architecture during the first two decades of the twentieth century, and by the mid-1930s most American cities had a planning department. Building codes, fire districts, and acceptable standards for everything from gas and electric lines to street widths became typical by the 1930s. In addition, banks and savings and loan institutions developed standardized procedures for property appraisal as well as commonly accepted ideas about what types of structures and spaces to encourage or discourage. Single-family houses, for example, were seen in a positive light, but residential hotels were frowned upon. Similarly, curvilinear residential streets were good, but alleys were bad. Front porches were an unnecessary expense and could easily be eliminated, but garages and driveways were essential. Corner stores were also discouraged on a number of counts: they mixed residential and commercial activities together and often had inadequate off-street parking. Every planner and lender gradually learned the rules. With the establishment of the Federal Housing Authority in the mid-1930s, planning and lending practices standardized, eliminating many of the interesting quirks of the traditional city.

Building to Code

In the years following World War II, the twin concepts of land-use planning and zoning were fully accepted. Heavily influenced by the pessimistic, antiurban view that different types of people and varying economic activities must be kept apart, segregation prevailed. For example, the Victorian idea of the

home as a refuge from the city gained nearly universal acceptance. Catch phrases such as "unsightly mixed uses" were readily called up to describe more traditional urban scenes. Codes and regulations, originally developed as a response to fires and other disasters, gradually expanded to cover everything from street widths to house color.

Beyond basic safety regulations, the justification for expanding codes was usually the protection of property values. The pessimistic view of society maintained that people had to be protected from one another. In residential areas, it was thought that, given the chance, some people would immediately paint their houses hideous colors and find abandoned trailers to put in weed-filled front yards. If corner stores and small parks were provided, they would only attract undesirables who hang out and cause trouble. If front porches were built, nosy neighbors could spy on others and, worse yet, walk over and bother people. On-street parking and narrow streets would lead to accidents, vandalism, ugly oil spots, and other problems. A grid pattern of streets would invite speeding traffic and strangers into the neighborhood, and if alleys were provided, unimaginable evils would likely abound there. Gradually, the typical house became more isolated, introverted, and fortresslike. The facade came to be dominated by massive, perpetually closed garage doors and paved driveways. The cul-de-sac became the location of choice. These trends often resulted in the demise of the gregarious house described in my first essay.

Similar pessimistic views also influenced the design of commercial areas. Too many doors, for example, would only encourage shoplifting and other criminal activity. Putting benches in plazas would encourage bothersome vagrants to sit on them. Stairways and decorative paving (even with the required handicapped options) would likely cause people to trip and sue

for damages. The construction of skybridges and tunnels, meanwhile, would eliminate the need for people to cross busy streets where they would likely be hit by a truck while distracted by a panhandler. For roughly a half-century (1930-1980), urban design was preoccupied with enclosing and protecting people. Vast blank walls and impersonal streets became the norm. While many have recognized the flaws built into this preoccupation, we have developed so many institutionalized procedures that it is difficult to change.

Those who seek to humanize city spaces now face an uphill battle. After decades of planning procedures aimed at protecting people from the spaces between buildings, it is arduous to argue that many types of traditional urban spaces work pretty well after all. Lenders balk at the possibility of creating spaces that may be perceived as dangerous and unpleasant by prospective residents or shoppers. In addition, there is the problem of liability. If a developer opts to make street widths narrower than the normal standards, it could entail legal liability should an accident happen. From most standpoints, the safest way to build anything is to follow the accepted national codes and standards. Inflexibility and pessimism are both built into the system.

There are also special interest groups to consider. One reason for the emphasis on having one vast, grassy open space in most newer residential developments and the relative disinterest in numerous small, vest-pocket parks is the influence of sports advocates. Soccer, baseball, and football supporters argue loudly for places in which community children can participate in sports, but few organized groups advocate neighborhood sociability. Organized sport means supervision and control, necessary dimensions of the pessimistic view of society. In downtown areas, the importance of advocacy groups is

even more obvious as ever-larger sports arenas, concert halls, convention centers, shopping centers, and parking garages drive out the small, informal spaces or "nooks and crannies" of spontaneous daily life. Indeed, "street people" has become a term of denigration.

The Hide-and-Seek City

The pessimistic view of human nature and the associated dislike of ad hoc public spaces has led to what I call the hide-and-seek city, wherein houses and apartments provide isolated, defensive places for people to hide from the rigors of urban life. Gated communities at the end of cul-de-sacs are examples of the more extreme versions of the phenomenon. Residents hiding in such refuges must deliberately seek out other dimensions of urban life by making long, often boring trips to major, enclosed, self-contained attractions. The trip likely consists of getting into a car in the garage at home and getting out in the garage of the final destination. Between the two poles, very little life exists in the ordinary spaces between buildings.

Many of these final destinations increasingly proclaim themselves to be "cities within a city," such that intervening spaces become irrelevant. Even baseball stadiums are being designed to have their own brew pubs, food courts, and shopping plazas so that fans can spend their entire day and night at doubleheaders. Life is safely enclosed at home, at work, and at play.

The topics discussed in the preceding three essays are all illustrated by the concept of the hide-and-seek city. Bland building facades, garage-dominated houses and apartments, walled and gated communities, grassy expanses at self-contained office "parks," heavily landscaped arterials, and massive, introverted structures connected with skybridges all epitomize the idea. Spontaneous activity in the ordinary spaces between buildings

is something to be avoided whenever possible; such is the message that this kind of urban space conveys.

Gaining Respect for the Optimistic View

Although they are increasingly rare, there are many places in North America where the ordinary and traditional spaces between buildings are alive and well. This is especially true in the central areas of many older but still exclusive suburban areas. In wealthy suburbs, where the price of property in combination with local political control and exclusionary zoning practices serve to keep out "undesirable" elements, traditional spaces can work remarkably well. Coronado, California, a suburb of San Diego, is a case in point. Coronado is a beach community located on an "island" (actually the tip of a long peninsula) in San Diego Bay. With homes starting at $300,000 and climbing to several million dollars, there is little concern that property values will plummet as a result of controversial urban design.

Coronado has nearly every type of urban space that the advocates of neotraditional urban design applaud. There is a grid of streets, and most have alleys behind them. The houses are gregarious, with either a garage in back on the alley or a small side-garage with a narrow driveway to the front. In both cases, the house facade is the dominant visual element. The houses are also close to the street, with small but meticulously kept front yards. Many of the houses have accessory apartments or "granny flats" over the alley garage, and most of the streets have a mix of houses and small apartment complexes. The commercial "main street" presents a solid street wall of small establishments with few visible parking lots. Parking is either on the street or in alley lots behind the establishments. There are no large discount retailers and no massive blank walls. Res-

idents pay big money to live in Coronado and claim to like it because it has a classic small-town feeling and they and their children can walk everywhere—to shops, to school, to church, to recreation, to friends. Similar upscale communities exist all across North America.

Traditional urban spaces also exist in many college towns, tourist towns, and gentrified big-city neighborhoods. Successful historic districts such as Georgetown or Alexandria in the Washington, D.C., area, Beacon Hill in Boston, and nearly every older neighborhood in San Francisco are also often built around pedestrian use of the spaces between buildings. These are all expensive places that depend, to some degree, on attracting and pleasing both residents and strangers—specifically, people with money. But we are not allowed to build these kinds of spaces any longer.

Most of the attempts at creating new, neotraditional neighborhoods that contain at least some of the elements that have made the above communities successful have been located in remote areas, far from anything or anyone that might threaten the investment. Famous examples, such as the Kentlands outside Gaithersburg, Maryland, or Seaside on the Gulf Coast of Florida, are quintessentially suburban and fairly expensive. The spaces are well designed, but there is little chance that the "wrong" people might discover them. Places not protected by defensive design, it seems, must be protected by a remote location. Most of these neotraditional developments still also have the full range of restrictive covenants protecting people from one another. Once again, the pessimistic view prevails. Without rules, everyone would paint their house purple or magenta.

The prevailing view is that traditional spaces between buildings facilitate and accentuate local behavioral patterns. This might be fine in a Spanish village in which everyone joins in the

Sunday paseo and passes time in sidewalk cafes or even in an American small town where everyone greets everyone else as a friend or acquaintance. In these cases, traditional spaces encourage acceptable behavior. In large, diverse American cities, however, one can never be sure who will move in and what their behavior will be. If homes have front porches, people might sit outside and party all night. If a neighborhood has straight streets, people will speed. Better to have spaces that discourage all behavior. Football coach Woody Hayes once explained his dislike for the forward pass by saying that three things could happen and two of them were bad. The same idea prevails in much of North American urban design; that is, most "street" behavior is likely to be bad, so planners and residents just opt for a "quiet" neighborhood with few opportunities for casual socializing.

Theories of Good City Form

Although this book is about the spaces between buildings, such spaces are really emblematic of more important urban issues. When we argue for certain types of spaces, be they front porches, alleys, sidewalks, or lawns, what are we really trying to achieve? In most cases the answer is necessarily vague. We seek some sense of community, sense of place, sense of belonging, sense of history, or feeling of involvement and participation. Most of these concepts are difficult to implement. Kevin Lynch made a start on this project in his book *Theories of Good City Form*. In it, he postulates several universals that make cities good places regardless of the cultural context or architectural heritage. A quick look at these may help us to understand some of the underlying issues involved in the creation of good spaces between buildings. Lynch's universals are vitality, fit, control, access, sense, and equity.

Presumably, the best cities are those that have all of the universals in a balanced combination. It is possible, however, to have a lot of one or two and a deficit in other categories. Therein lies the trade-off with regard to types of urban spaces.

Vitality refers to the idea that good cities should support life and health. Cities with high levels of pollution, crime, and occupational hazards do not have vitality. To the extent that good urban spaces contribute to mental health and a sense of belonging, this topic is especially relevant to our discussion. Urban spaces are related to basic vitality issues. Certainly trees and other forms of greenery may contribute to air quality at the same time that chemicals and other fertilizers used to enhance that greenery may contribute to pollution levels. Similarly, levels of automobile usage also affect air quality.

Fit refers to the way that urban spaces relate to the human body and the activities we engage in. Clearly the issue of human scale is of importance here. Finding good places in which to walk, sit, relax, talk, eat, and perhaps even meditate all illustrate the idea of fit. The lack of fit in many of our cities is well-illustrated by people waiting in the rain at a busy highway bus stop or trying to sit on a downtown plaza wall where wrought iron spears have been planted to dissuade them. Any place that children play or old folks sit and talk demonstrates the concept of fit.

Control is also important. We want to feel that we are in control of our homes, neighborhoods, and cities and that we have the power to channel and direct the activities that go on in and around our turf. Perhaps as society is perceived to be increasingly out of control, our need for individual control over our immediate environment increases. This may explain the popularity of fortified houses, gated communities, restrictive covenants, and introverted malls. An excessive concern with

CITY SPACES AND HUMAN NATURE

control, however, can diminish the role of other universals such as access.

Access implies that people of all ages and classes will be able to get to the places they want to go with a minimum of hassle and dependency. In an environment with good access, children can get to school, playgrounds, and the homes of friends, and the elderly can get to shops, medical centers, and restaurants. With the advent of the telephone, television, and the internet, information and communication can, to some degree, be obtained electronically, but physical access is still important to ward off isolation. We still need "third places" like pubs, coffee houses, libraries, places of worship, and parks where we can meet people on a casual basis. One of the main issues of urban space design is the trade-off between levels of access and control. For the most part, we have opted for control to the detriment of access. As a result, children must be driven everywhere and many elderly lead lives of isolation.

Sense refers to the visual, aural, and olfactory stimulation that good places provide. Such places reveal a unique emotional character; they have a sense of place. European cathedrals, Guatemalan markets, and New York subways all have memorable sights, sounds, and smells that require total involvement. We have tended to treat this universal as unimportant. People have instead opted for chain restaurants and discount stores, characterless highways, and bland suburbs. Most of the interesting spaces of my own childhood, from tree houses and alley forts to children decorating the commercial buildings for holidays, are no longer allowed in most places.

Finally, there is the matter of *equity*. It takes more than good urban design to ensure social equity, but design can play a role. Certainly a greater mix of housing types, including alley housing and housing over shops, meant that many traditional neigh-

borhoods were far less segregated along economic lines than the homogeneous suburbs of today. Similarly, the existence of many small storefronts along busy sidewalks meant that petty entrepreneurs with limited access to capital may have had more opportunities in traditional settings. Today, the lack of access to clean, safe, and stimulating environments may be an important factor in the creation of an American underclass.

Look around. The ordinary, everyday spaces between buildings may be more important than you think. These spaces are, or should be, the public city.

BIBLIOGRAPHY

Anderson, Stanford, ed. 1978. *On Streets*. Cambridge, Mass.: MIT Press.

Appleyard, Donald. 1981. *Liveable Streets*. Berkeley: University of California Press.

Barnett, Jonathan. 1986. *The Elusive City: Five Centuries of Design, Ambition, and Miscalculation*. New York: Harper and Row.

———. 1995. *The Fractured Metropolis: Improving the Old City, Restoring the New City, Reshaping the Region*. New York: HarperCollins.

Barnett, Roger. 1978. "The Libertarian Suburb: Deliberate Disorder." *Landscape* 22, no. 3: 44–48.

Bernick, Michael, and Robert Cervero. 1997. *Transit Villages of the Twenty-first Century*. New York: McGraw-Hill.

Borchert, James. 1980. *Alley Life in Washington: Family, Community, Religion, and Folk Life in the City, 1850–1970*. Urbana: University of Illinois Press.

Bormann, F. Herbert, Diana Balmori, and Gordon T. Gaballe. 1993. *Redesigning the American Lawn*. New Haven: Yale University Press.

Calthorpe, Peter. 1993. *The Next American Metropolis: Ecology, Community, and the American Dream*. Princeton: Princeton Architectural Press.

214

Carson, Rachel. 1962. *Silent Spring*. Cambridge, Mass.: Riverside Press.

Chermayeff, Serge, and Christopher Alexander. 1963. *Community and Privacy: toward a New Architecture of Humanism*. New York: Doubleday.

Clay, Grady. 1973. *Close-Up: How to Read the American City*. Chicago: University of Chicago Press.

———. 1978. *Alleys: A Hidden Resource*. Louisville, Ky.: Louisville Design Center.

Clark, Clifford. 1986. *The American Family Home, 1800–1960*. Chapel Hill: University of North Carolina Press.

Ellin, Nan. 1996. *Postmodern Urbanism*. Cambridge: Blackwell Publishers.

———, ed. 1997. *The Architecture of Fear*. Princeton: Princeton Architectural Press.

Fishman, Robert. 1986. *Bourgeois Utopias*. New York: Basic Books.

Ford, Larry. 1994. *Cities and Buildings: Skyscrapers, Skidrows, and Suburbs*. Baltimore: Johns Hopkins University Press.

Francaviglia, Richard V. 1996. *Main Street Revisted: Time, Space, and Image Building in Small Town America*. Iowa City: University of Iowa Press.

Garreau, Joel. 1991. *Edge City: Life on the New Frontier*. New York: Doubleday.

Girouard, Mark. 1985. *Cities and People: A Social and Architectural History*. New Haven: Yale University Press.

Goin, Peter. 1984. "Anonymous Places." *Landscape* 28, no. 1: 24–29.

Goldsteen, Joel B. and Cecil D. Elliott. 1994. *Designing America*. New York: Van Nostrand Reinhold.

Gramp, Christopher. 1985. "Gardens for California Living." *Landscape* 28, no. 3: 40–47.

———. 1988. "The Well-Tempered Garden: Gravel and Topiary in California." *Landscape* 30, no. 1: 41–47.

Gratz, Roberta Brandes, and Norman Mintz. 1998. *Cities Back from the Edge: New Life for Downtown*. New York: John Wiley and Sons.

Groth, Paul. 1990. "Lot, Yard, and Garden: American Distinctions." *Landscape* 30, no. 3: 29–35.

Hayden, Dolores. 1984. *Redesigning the American Dream*. New York: Norton.

Hough, Michael. 1990. *Out of Place: Restoring Identity to the Regional Landscape*. New Haven: Yale University Press.

Jackson, Kenneth. 1985. *Crabgrass Frontier: The Suburbanization of The United States*. New York: Oxford University Press.

Jacobs, Allan. 1985. *Looking at Cities*. Cambridge, Mass.: Harvard University Press.

———. 1993. *Great Streets*. Cambridge, Mass.: MIT Press.

Jacobs, Jane. 1961. *The Death and Life of Great American Cities*. New York: Vintage Books.

Jenkins, Virginia Scott. 1994. *The Lawn: The History of an American Obsession*. Washington, D.C.: Smithsonian Institution Press.

Katz, Peter. 1994. *The New Urbanism: Toward an Architecture of Community*. New York: McGraw-Hill.

Kostof, Spiro. 1987. *America by Design*. Oxford: Oxford University Press.

———. 1991. *The City Shaped: Urban Patterns and Meanings through History*. Boston: Bullfinch.

Kunstler, James Howard. 1993. *The Geography of Nowhere: The Rise and Decline of America's Man-Made Landscape*. New York: Simon and Shuster.

Langdon, Philip. 1994. *A Better Place to Live: Reshaping the American Suburb*. Amherst: University of Massachusetts Press.

Liebs, Chester. 1995. *Main Street to Miracle Mile: American Roadside Architecture*. Baltimore: Johns Hopkins University Press.

Longstreth, Richard. 1987. *The Buildings on Main Street: A Guide to American Commercial Architecture*. Washington, D.C.: Preservation Press.

Lynch, Kevin. 1981. *A Theory of Good City Form*. Cambridge, Mass.: MIT Press.

McKenzie, Evan. 1994. *Privatopia: Homeowners Associations and the Rise of Residential Private Government*. New Haven: Yale University Press.

Moe, Richard, and Carter Wilkie. 1997. *Changing Places: Rebuilding Community in the Age of Sprawl*. New York: Henry Holt and Company.

Newman, Oscar. 1973. *Defensible Space: Crime Prevention through Urban Design*. New York: Macmillan.

Norquist, John O. 1998. *The Wealth of Cities: Revitalizing the Centers of American Life*. Reading, Mass.: Addison-Wesley.

Olsen, Donald. 1986. *The City as a Work of Art: London, Paris, Vienna*. New Haven: Yale University Press.

Relph, Edward C. 1987. *The Modern Urban Landscape: 1880 to the Present*. Baltimore: Johns Hopkins University Press.

Rifkind, Carole. 1977. *Main Street: The Face of Urban America*. New York: Harper and Row.

Riis, Jacob. 1890. *How the Other Half Lives. Studies of the Tenements of New York*. New York: Charles Scribner's Sons.

Rotenberg, Robert, and Gary McDonogh, eds. 1993. *The Cultural Meaning of Urban Space*. Westport, Conn.: Bergin and Garvey.

Rowe, Peter G. 1991. *Making a Middle Landscape*. Cambridge, Mass.: MIT Press.

Rudofsky, Bernard. 1969. *Streets for People: A Primer for Americans*. Garden City: Doubleday.

Schery, Robert W. 1961. *The Lawn Book*. New York: Macmillan.

Schroeder, Fred. 1993. *Front Yard America: The Evolution and Meaning of a Vernacular Domestic Landscape*. Bowling Green, Ohio: Bowling Green State University Popular Press.

Schuyler, David. 1986. *The New Urban Landscape: The Redefinition of City Form in Nineteenth-Century America*. Baltimore: Johns Hopkins University Press.

Siksna, Arnis. 1997. "The Effect of Block Size and Form in North American and Australian City Centers," *Urban Morphology* 1 (1997): 19–33.

Sorkin, Michael, ed. 1992. *Variations on a Theme Park: The New American City and the End of Public Space*. New York: Noonday Press.

Southworth, Michael, and Eran Ben-Joseph. 1997. *Streets and the Shaping of Towns and Cities*. New York: McGraw-Hill.

Stilgoe, John R. 1988. *Borderland: Origins of the American Suburb, 1820–1939*. New Haven: Yale University Press.

Sudjic, Deyan. 1992. *The 100-Mile City*. San Diego: Harcourt, Brace, and Company.

Tuan, Yi-Fu. 1984. *Dominance and Affection: The Making of Pets*. New Haven: Yale University Press.

Venturi, Robert, Denise Scott Brown, and Robert Izenour. 1988. *Learning from Las Vegas*. Cambridge, Mass.: MIT Press.

Vance, James E. Jr. 1990. *The Continuing City: Urban Morphology in Western Civilization*. Baltimore: Johns Hopkins University Press.

Whitaker, Craig. 1996. *Architecture and the American Dream*. New York: Random House.

Whyte, William H. 1968. *The Last Landscape*. Garden City: Doubleday.
———. 1988. *City: Rediscovering the Center*. New York: Doubleday.

Wolfe, Tom. 1965. *The Kandy Kolored, Streamline, Tangerine-Flake Baby*. New York: Farrar, Straus, and Giroux.

INDEX

INDEX

223

About the Author

LARRY R. FORD was born in Enid, Oklahoma, in 1943, and raised in a variety of places, mostly Columbus, Ohio. He received his B.S. and M.A. in geography at the Ohio State University and completed his Ph.D. in geography at the University of Oregon in 1970. He then joined the faculty of the Department of Geography at San Diego State University, where he became a full professor in 1977. For the past thirty years he has published widely in leading professional journals in the areas of urban preservation, comparative city structure, and the relationship between architectural traditions and urban morphology. His books include *Cities and Buildings: Skyscrapers, Skidrows, and Suburbs* (1994) and, with E. Griffin, *Southern California Extended.* He is currently working on a book about the history and changing character of downtowns in America and elsewhere for the Creating the North American Landscape series.

LIBRARY OF CONGRESS CATALOGING-IN-PUBLICATION DATA

Ford, Larry.

 The spaces between buildings / Larry R. Ford

 p. cm. — (Center books on space, place, and time)

 Includes bibliographical references and index.

 ISBN 0-8018-6330-9 (alk. paper) — ISBN 0-8018-6331-7 (pbk. : alk. paper)

 1. Public spaces—United States—History—20th century. 2. City planning—United States—History—20th century. I. Title. II. Series.

NA9053.S6 F67 2000

711′.4 21—dc21

 99-042525